200
PROJECTS
TO GET YOU INTO
ART
SCHOOL

200 PROJECTS
TO GET YOU INTO
ART SCHOOL

Valerie Colston

BLOOMSBURY
LONDON · NEW DELHI · NEW YORK · SYDNEY

A QUARTO BOOK

First published in the UK in 2008 by
A&C Black Publishers Ltd
An imprint of Bloomsbury Publishing plc
50 Bedford Square
London WC1B 3DP
www.bloomsbury.com

Reprinted 2009 (twice), 2010, 2012

This reprint (2014) published by Bloomsbury Visual Arts
An imprint of Bloomsbury Publishing plc

Copyright © 2008 Quarto Publishing plc

ISBN 978-0-7136-8799-6

A CIP record for this book is available from the
British Library.

Conceived, designed and produced by
Quarto Publishing plc
The Old Brewery
6 Blundell Street
London N7 9BH

QUAR.TTAT

Project editor: **Anna Amari-Parker**
Managing art editor: **Anna Plucinska**
Designer: **Julie Francis**
Copy editor: **Anna Amari-Parker**
Additional text: **Sheila Coulson, Patsy North**
Art director: **Caroline Guest**
Picture researcher: **Claudia Tate, Gwen Campbell**
Proofreader: **Ruth Patrick**
Photographers: **Simon Pask, Phil Wilkins**
Indexer: **Dorothy Frame**
Creative director: **Moira Clinch**
Publisher: **Paul Carslake**

Color separation by PICA Digital Ltd, Singapore
Printed in China by
1010 Printing International Ltd.

9 8 7 6

Contents

Introduction

On average, only seventy-five per cent of all applicants who apply to the art school of their choice are accepted. In some cases, this figure may be as low as eight per cent, depending on the level of competition and quality of applicants. It's not that a potential student doesn't want or deserve to get in, but there are simply too many applicants for too few places. *200 Projects To Get You Into Art School* gives you a concerted plan of attack that maximises your chance of success. Effectively an art classroom in a book, it will prepare you to achieve your goal by challenging your perception, inspiring your thinking, and developing your existing art skills.

In the same way that a winning athlete or runner cannot win a race without training for months or even years, an aspiring artist cannot build up a successful body of work overnight. Remember that what you present at admission time will be the strongest indicator of your artistic capability in the eyes of an interviewer – in some cases, *the* factor. There is no substitute for a strong portfolio full of interesting work, but how do you develop a comprehensive body of work? What types of projects should you include in your submission? This book answers these questions and more.

Written by a qualified art professor, *200 Projects To Get You Into Art School* is organised like a master class. Its four modules are dedicated to line, markmaking and ideas; colour and tone; texture and pattern; form and

space. These elements constitute the main tools of any respected artist. **Innovative demonstrations**, **projects** and **teaching points** within each module challenge the reader at every turn. **Close-up shots**, **practical and easy-to-apply technical demonstrations**, as well as **colourful illustrations** round out the chapters. Many pages contain a useful **virtual gallery** panel that takes the lesson one step further by encouraging use of the Internet as a way of exploring additional concepts and ideas. The section on **techniques**, **tools**, **materials** and **building up a strong portfolio** at the back of the book will help any aspiring artist to create quality, expressive and technically sound art that will get noticed!

Each workout presents the opportunity of experimenting with a **variety of media**. The exercises don't assume technical prowess, but use **clear and simple language** to review basic techniques, promote ideas and encourage further study. The book's pace is fast, fun and contains themes and projects that will be of interest to a young audience. *200 Projects To Get You Into Art School* is aimed at art school aspirants, high school students, educators and anyone looking for innovative, high-quality art exercises.

Although completing the workouts in this book might not guarantee your admission into art school, it will give you a good fighting chance. Learn to create art that reflects your understanding of basic drawing principles, shows your versatility using a variety of media, and gives you the necessary motivation to produce a memorable body of work in your own style.

Themes and projects

Welcome to an art school in a book. Four creative modules and
a techniques section contain visual concepts and essential skills
to open your eyes, challenge your thinking and kickstart your
creativity. Work through in order or dip in wherever you like.

MODULE

1

Lines, marks, shapes, ideas

"A line is a dot that went for a walk." **PAUL KLEE**

As a child you probably scribbled away with delighted abandon. Module 1 will help you

return to those uninhibited days and reconnect with your natural creativity. Once you

understand the expressive powers of lines, marks and shapes, you can use this knowledge

to explore your visual ideas and investigate each new subject with greater confidence.

Types of line

One of the most powerful elements in art, lines are usually the first marks in a composition. Throughout the creative process, they help kickstart, develop and organise artwork.

You, the artist, are in control and can manipulate line through different techniques, media, tools and surfaces. Understanding lines and what they can do for your compositions will help you become more confident about your drawing abilities. Use gestural lines to explore movement and proportion in figure drawings and contour lines to "see" your subject and manipulate the placement of colour, shape and other elements to produce implied lines. You can also use quality of line to create one- or two-point perspectives, patterned textures and distorted shapes.

② Continuous lines

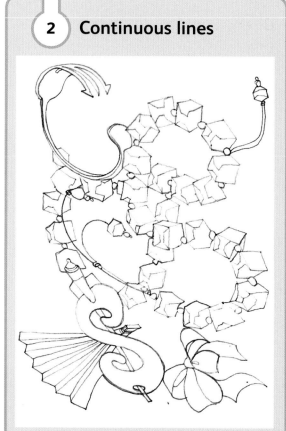

Uninterrupted lines or repeating line patterns convey character, movement and dynamism. Use any medium to draw or paint a composition composed only of continuous lines. Do it without taking your hand off the piece of drawing paper. Now ask a fellow art student or group of students to continue where you left off, perhaps using a different colour. Observe how the subject and style changes. The results are intriguing. Now try listening to some music and let the notes guide the movements of your hand.

① Gestural lines

More than just sketches, gesture drawings help you to develop an artist's eye and explore your ability to create interesting, figurative action lines. The secret formula to a successful drawing is hard concentration and a quick hand. The more you practise, the faster and better you will become. Here's the challenge. You've got less than one minute to capture movement in any of these dynamic figures: your friend shooting a basketball through the hoop, your favourite musician performing or your pet chasing a ball. Use your sketchbook or newsprint pad, and a soft lead pencil to create scribbly, loose, flowing lines. No erasers are allowed. You can also invent your own lines.

Ask a friend to sit on the floor and get him or her to fidget for a few minutes. Keep drawing until you capture the movement that is involved.

Implied lines

In a composition, lines can be literal or implied. Implied lines allow the viewer to fill in the blanks and "invent" linear strokes that, while not actually drawn, are perceived through the interaction, placement and relationship of lines, shapes or colours close to one another. Find implied lines in nature or around your neighbourhood. Have you ever watched ice skaters in action? As they move past you, your eyes read the curving twists and turns as flowing lines. If the artist drops his or her line in contour drawing, the eyes of the viewer will pick it up again to finish off the piece.

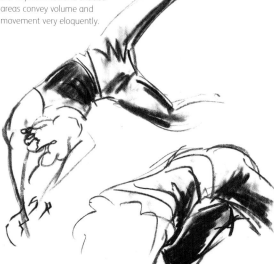

Although these gestural drawings of an athlete doing a somersault and a backflip do not have well-defined feet or hands, the implied lines and shaded areas convey volume and movement very eloquently.

3

Directional lines

Just as lines conduct the traveller through the contours of a map, directional lines guide the viewer through a composition. As an artist, you have the power to determine where to place them for emphasis. Imagine you are taking your onlooker through the compostion, either on a frenetic rollercoaster ride or gentle walk through the woods. Draw a skateboarder in action using directional lines to indicate the direction of dynamic movement.

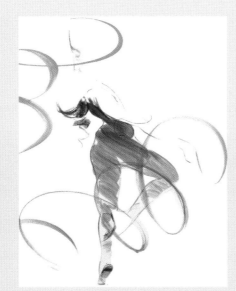

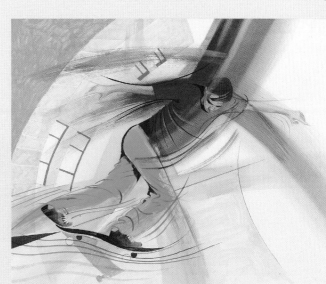

At first glance, the eye is attracted to the fluid red brushmarks on the body of the gymnast. It is led first down then up to the ribbon spirals.

The red element again pulls the viewer's eye down in a forward-moving diagonal from the top right edge of the composition towards the skateboard. Contrasting lines balance the piece and add dynamism.

4 ## Outlines and contour drawing

Outlines follow the outside edges of a subject. These kinds of lines can be worked as a continuous line drawing – where you look at your paper from time to time – or through a blind drawing process, where you purposely avoid peeking at your paper or canvas until you are finished. You can modify any outline drawing by switching hands or adding textural accents and mixed media to your initial linework. Practise your drawing and painting skills further by tracing the outside edges of figures and objects in nature and other environments. Contour drawings describe the form of the object, a little like drawing a series of hoops around an arm to explain its shape. The English sculptor Henry Moore used this method of observational drawing in many of his figure compositions or sketches.

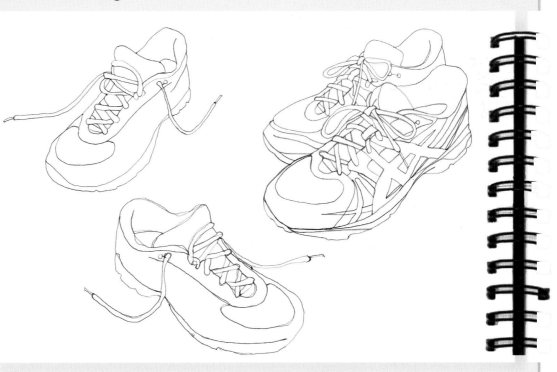

Choose a simple, everyday subject such as a trainer and draw its outline. Getting the shape right without any interior lines to help guide your measurements can be tricky. Attempt a second sketch, this time including more visual information (for example, the laces). Finally, draw all the details on the shoe. The curving shapes of its structure and decoration are similar to contour lines because they follow a 3D shape.

5 ## Virtual gallery

Paul Getty Museum Study the lines in Théodore Gericault's equestrian sketches. www.getty.edu/art/gettyguide/ artobjectdetails?artobj=246

6 Describing lines

Lines have wide-ranging descriptive and emotional qualities that you can personalise to your own marks: a dark, bold line is heavy and overpowering; thin lines appear delicate; uneven, choppy lines read as unstable. Thick and powerful, fine and delicate, zigzagged and nervous, lines are unique with their own, built-in code. Each has a specific look and the capacity to express emotion or describe form. The quality and character of different lines will help your artwork to communicate powerfully.

Put together a reference list of all the different kinds of lines you can think of to incorporate into your compositions. Draw each one, then think of adjectives that reflect their character and emotive properties. Write them down. Add to the list as often as possible. Below are a few examples to get you started.

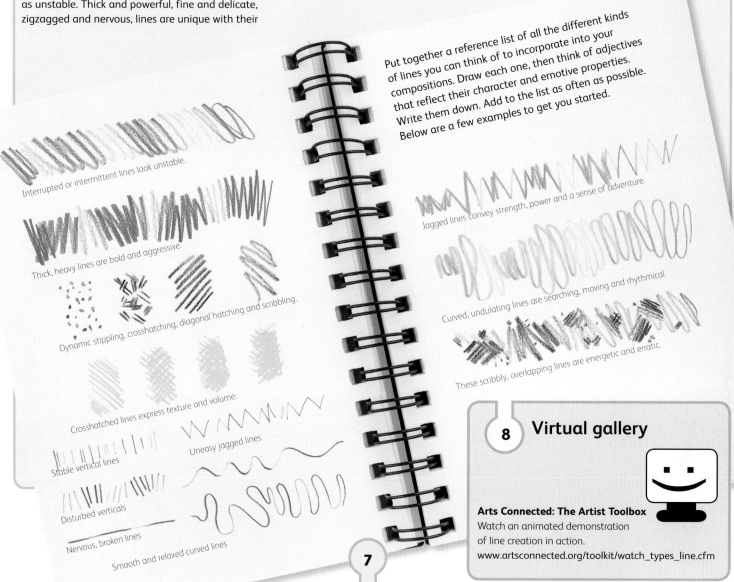

Interrupted or intermittent lines look unstable.

Thick, heavy lines are bold and aggressive.

Dynamic stippling, crosshatching, diagonal hatching and scribbling.

Crosshatched lines express texture and volume.

Stable vertical lines

Uneasy jagged lines

Disturbed verticals

Nervous, broken lines

Smooth and relaxed curved lines

Jagged lines convey strength, power and a sense of adventure.

Curved, undulating lines are searching, moving and rhythmical.

These scribbly, overlapping lines are energetic and erratic.

8 Virtual gallery

Arts Connected: The Artist Toolbox
Watch an animated demonstration of line creation in action.
www.artsconnected.org/toolkit/watch_types_line.cfm

7

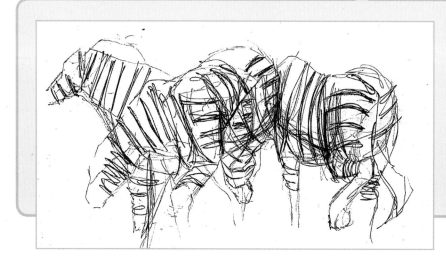

Nature's own

Visit the zoo or take a virtual safari tour online. Be inspired by the linework on the bodies of richly patterned animals such as tigers and giraffes.

Observe just how effectively the hatched lines (left) describe the pattern and anatomical shape of a herd of grazing zebras.

Figuratively speaking

Whether through line, observational, gestural, figurative or conventional drawing, figure drawing is vitally important to the art student.

Artists gain an in-depth understanding of one of art's key visual forms through study of the human form, and also of the inner motivation, personality, mood and character of the model or groups they are rendering. A figure drawing reveals something about the artist's own insight and feelings towards the sitter.

10

Observational drawings

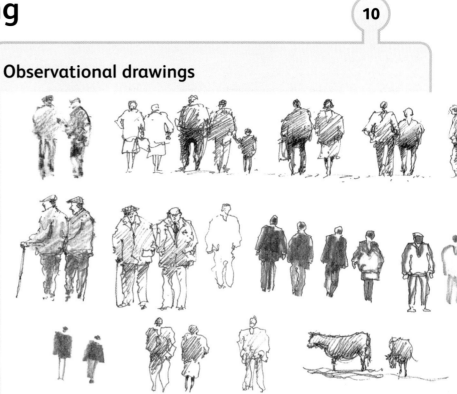

Analyse body language in general and study the specific proportions of individuals of all ages, shapes and sizes (see above). Observe how the shoulders are the widest part in males, whereas in females it is the hips. In children, the head is proportionally larger than the body. Sketch each individual's shape using quick strokes before proceeding to hatch in areas of tone or shading.

9 Contour lines

Artists use contour lines to capture action and movement. Study a dancer's gestures, either in real life or from a photograph. Notice how the lines in the first illustration (below) overlap one another to create an "after image" that reinforces the manner and direction of the dancer's movement. Apply this technique to your work, creating a sense of rhythm.

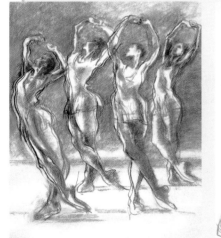

The Impressionist artist Edgar Degas spent hours observing dancing ballerinas. He recorded their movements and individual personalities through painting, sculpture and sketching.

Study a group of dancers (above). Make a contour drawing of the troupe as a whole. Exaggerate and elongate these outlines to express emotion and gracefulness or capture the overlapping lines of one dancer as she twirls around.

11 Figure proportions

To improve your basic observational drawing skills, it is useful to be aware of the head-to-body ratios in both male and female figures (below). In females, the head fits inside the length of the body about 8.5 times on average. This number increases to 9 in males. Decide on the type of figure you want to sketch. Cut out a photograph from a magazine. Enlarge it and mark the proportions before you start.

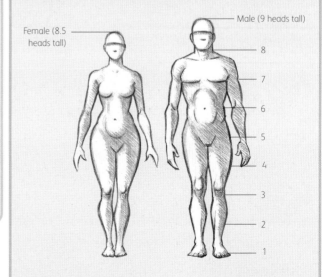

Female (8.5 heads tall)

Male (9 heads tall)

12 Action figures

Good figure drawing describes movement accurately. This exercise will give you the confidence to draw quick, emotive line sketches of figures on the move. Use an artist's mannequin to observe what happens to the standard body proportions as a figure moves through space. Draw the body as a series of basic shapes, almost like a geometric sketch. This abstract simplification will help you see the foreshortening effect that different viewpoints or angles have on certain body parts. Flesh out your figure, making line quality descriptive of shape. Draw your figure walking, running or skiing.

The right thigh is a fairly standard length but looks longer than the left.

Foreshortening or perspective makes the left thigh appear much shorter.

13 Combining gestural and implied line

Movement, time and place may be suggested through gestures and implied lines. The artist conveys movement by depicting two figures walking together through a train station (right). Although indistinct, gestural lines indicate they share the same physical space. The legs and feet of the pair and the city and structures in the background are implied for added effect.

For this style of painting, hold your brush in your hand and manipulate it so it becomes a tool for creating loose, indistinct lines that reflect movement and subtle effects. Allow your viewer's imagination to fill in the rest.

14 Drawing loners, pairs and groups

When you sketch an individual figure or include this figure as part of a group, it's important to preserve the integrity of your drawing. The portfolio page on the right shows two separate drawings placed side by side. This arrangement enhances the interpretation of the composition because even though the young men share the same space, each figure tells an individual story.

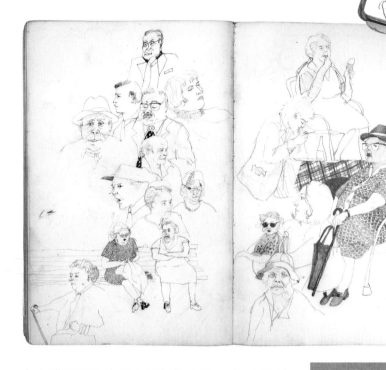

In the illustrations above, individuals are grouped in a vaguely pyramidal shape. The seated figures in the foreground are foreshortened for depth and perspective. Observe how, although the artworks function as a unit, each character remains a separate study.

The above sketch assembles the observed participants into three collective units.

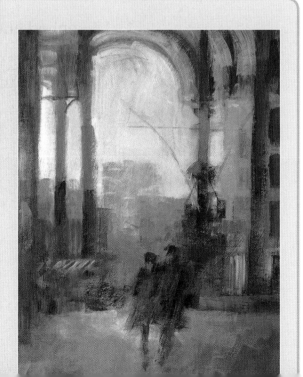

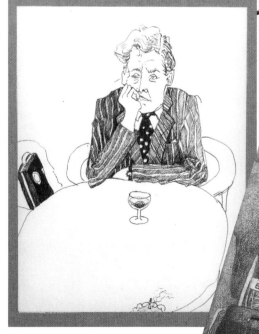

Figure drawings convey mood (the lonely man at the table, above) and use setting to tell a story (the woman waiting at the airport, right). Draw one example of each and include the best work for your portfolio.

Silhouettes on show

Drawing shapes accurately without any points of reference can be surprisingly difficult. This technique relies on being able to see and then draw the basic outlines of objects and figures.

Originally created as an art form for eighteenth-century royalty before photography was invented, silhouettes have stark outlines, simple shapes and no expression yet still mysteriously convey the essence of an object or figure. Silhouette styles can be traced back to primitive cave art and have many descriptive and expressive uses in fashion (as designs), in art (as a way of making intricate paper patterns) and in photography (as beautiful landscapes).

16 The shape of things

Go on a scavenger hunt in search of different objects such as a guitar, a pair of trainers or a teddy bear. Locate at least 10 common household items. Make a silhouette of each object using either photography, black paper cutouts glued to white board, a digital paint program on your computer or handpainting. Use and manipulate the silhouettes to form a new composite object. See if your friends are able to recognise the original objects.

15 Making silhouettes "read"

Figure silhouettes inspire interesting gestural compositions. Create a series of silhouetted action figures using a variety of media. Use scissors and black construction paper to cut out these characters. Ask friends to strike up different poses. Make a series of action figures or movie characters, creating an appropriate background for each. Let the figure dictate the backdrop. Notice how the old man (right) is easier to "read" in profile, but far more ambiguous to decipher when viewed head-on.

Carefully consider the shape or angle that you want before drawing or cutting out your silhouette because some angles and some shapes give away more visual information than others.

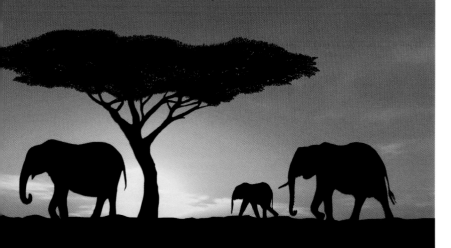

17 Photographic silhouettes

Wait until sundown before visiting your favourite nature haunt armed with a digital camera. Take a snapshot of a tree, a person or an object with the sun behind them. For example, a seagull against the setting sun, a boat downriver or a skier against the winter sky. Pick the best photograph of objects in silhouette, then develop it and frame it. If you want to armchair travel, imagine you are on safari in Africa. Picture the distinctive outlines of a family of elephants travelling across the savannah (above).

19 Virtual gallery

Silhouette Sytes Organisation
View dozens of stunning photographic silhouettes.
http://silhouettes.sytes.org/

Fashion Era Silhouette Web site Print out fashion silhouettes to use in collage work.
http://fashion-era.com/C20th_costume_history/black_silhouettes_1920_1930.htm

18 Refine your observational skills

Create expressive portrait cutouts from black art paper, incorporating as many props or hand gestures as you can. Use a model or a famous sculpture as inspiration or find photographs of people in profile with distinguishing features, such as the young man with short, cropped hair or the moustached old man with the ponytail and cane (right).

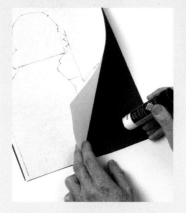

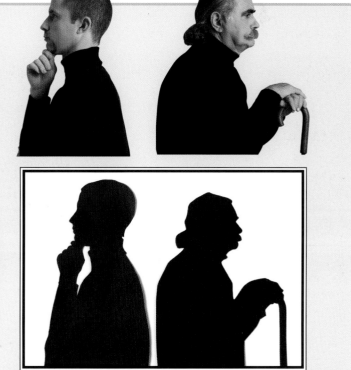

1 Draw an outline of both figures in pencil. Glue the drawing onto black paper or cardstock.

2 Cut around the outline image.

3 Flip the cutouts over, so the black side is face up.

Observing and drawing faces

The human face can be expressed in myriad ways. After getting to grips with its basic structure, use line and shape in creative ways to convey the unique character of any sitter.

Viewers communicate with portraits usually without knowing anything about the sitters, except what the painting tells them. What do portraits communicate? They give away the age, sex, personality and lots more about the subject. From formal portraits to zany caricatures, these artworks can be shared with friends and family, used to promote celebrities or political leaders, find criminals or explore an artist's life (as in the self-portraits of Rembrandt and Van Gogh, for example).

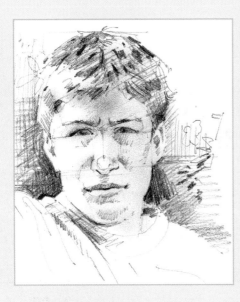

Finding your own style **20**

Portraits can be created in a variety of media, including paint, pencil, pastel, clay and photography.

Realistic drawings
The aim here is total realism. Try to capture an accurate likeness of your model (left). This is tricky when you're starting out, but the exercises in this book will help you find your way.

Cartoon-style drawings
Graphic sketches (right) usually exaggerate certain physical attributes such as the ears and eyes. Even in this wacky style, your subject should still be recognisable. Focus on something that's distinctive such as an item of clothing, a prominent facial feature or a prop that he or she is never seen without. Make this the focus.

Manga mania
Stylisation is probably the most significant recurring element in manga artwork (left). Be sure to give your subject big eyes and vibrant, shiny highlights.

Keeping a sketch diary **21**

Begin a sketch diary. Draw your friends, family, favourite band or celebrities. Provided they've got a face or a head, they will all belong in your sketch diary! Look in the mirror and try sketching your own face from different angles with different expressions.

Hang out with skateboarders for some truly great action sketches. Capture their poses and expressions.

Ask a friend to describe someone you have never seen in detail. Draw a portrait of this person from the description given and see how close you come to a true likeness (right).

Sketch someone on a car journey with you (below). Your lines will be wobbly, but you will be less self-conscious about "drawing straight". (It's one of the first exercises that art students do.)

👁 **see also**

Having fun with the human figure, page 96

22 Facial proportions

Copy a photograph of a face. Draw a grid over it to explore facial symmetry and balance.

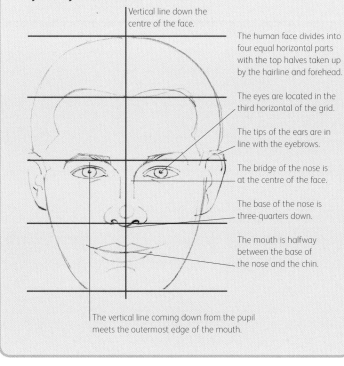

Vertical line down the centre of the face.

The human face divides into four equal horizontal parts with the top halves taken up by the hairline and forehead.

The eyes are located in the third horizontal of the grid.

The tips of the ears are in line with the eyebrows.

The bridge of the nose is at the centre of the face.

The base of the nose is three-quarters down.

The mouth is halfway between the base of the nose and the chin.

The vertical line coming down from the pupil meets the outermost edge of the mouth.

23 Getting the balance right

1 Tear a headshot from a magazine. Cover half the face with a folded sheet of thick paper. Draw the half you cannot see. Try to balance out the features. Use your pencil as a measuring device (see the face diagram opposite). No peeking!

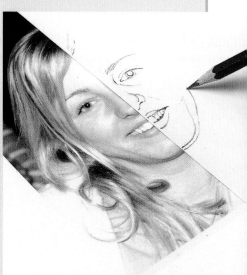

2 When you have completed one side, assess the accuracy of your mirror image.

3 Repeat using the other side of the face and the folded paper.

25 Virtual gallery

Emotional Expressions Match up the correct eye and mouth combinations to illustrate specific emotions.
http://www.dushkin.com/connectext/psy/ch10/facex.mhtml

24 Manipulating expressions

Are you a good judge of character? Perhaps you think you can judge someone's personality just by looking at their face. Research studies show that ninety per cent of people believe they can. Using a digital computer program such as Adobe Illustrator, start with a neutral expression as a template (right). Choose a selection of features, such as different kinds of mouths and eyebrows. Have fun scrambling up the various combinations then superimpose them onto a face. Repeat this until you have a series of expressions. You can personalise the hairstyle, hair colour and skin tone (right) or design your own smiley face series (below).

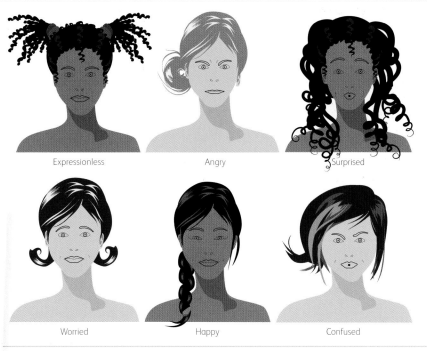

Expressionless Angry Surprised

Worried Happy Confused

Lines and patterns in nature

Miraculous and inspiring, lines and patterns occur everywhere in nature. Take a fresh look at familiar natural subjects, notice their wonderful designs and use them in your work to express what you see.

The natural world is a constant source of inspiration for artists, and no wonder! If you look at nature with fresh eyes, you'll begin to notice a wealth of texture and pattern. Look for amazing symmetry, repeated swirls and stripes, sharp jagged lines or soft curves. Harnessing these natural wonders will help you bring out the essence of any natural subject that you choose to tackle.

26 Close-up of a vegetable patch

Follow in the footsteps of Renaissance artists such as Leonardo da Vinci and Albert Dürer, who took real delight in observing and recording the design of flowers, plants, leaves and trees in great scientific detail on their outings. Take your sketchbook and digital camera with you as you stroll through a botanical garden or visit an urban vegetable patch. Focus on how lines form intricate patterns and textures in objects such as wild mushrooms and onions (below). Record these natural designs in your art journal or sketchbook.

27

Same subject, different approaches

You can convey the textures and patterns of a landscape in different ways. First use smudgy marks and areas of tone in soft pencil or charcoal, then repeat the exercise using defined linear marks or combine the two to describe the natural textural differences between, say, foliage and water.

A painterly approach softens and diffuses any scene.

Pencil, pen and ink produce a harsher, more linear effect.

28 Virtual gallery

Huntington Botanical Gardens
Take a virtual tour of the conservatory's digital garden.
www.huntingtonconservatory.org/

29 Landscape as a patchwork of patterns

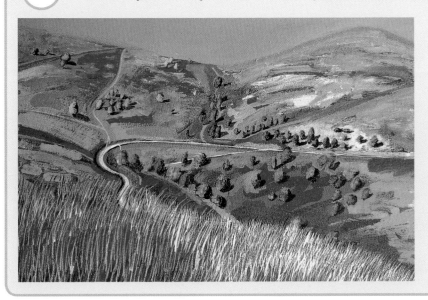

The natural environment provides artists with an endless wealth of challenging and inspiring subjects to paint. At first glance a landscape can seem complex. However, study it for a bit longer and you'll find that it is composed of intriguing patterns of shape and line that help to lead the eye around the scene. Exploit these elements to simplify things and help you create an exciting composition.

In this richly patterned landscape (left) the artist uses the patchwork of distant fields and hills and the powerful curving line of the lane to create a vibrant composition. The blocks of colour in the background contrast with the linear texture of the foreground grass to create a real sense of distance.

30 Collect it: looking for lines in nature

Symmetry is nature's fundamental principle of organisation: tree rings, cracks in bark, watery ripples, whorls on seashells and lines in the sand are just a few examples. Artists look out for such patterns but also like to create their own. By varying the relationships within patterns where symmetry is expected, otherwise predictable and repetitive patterns can be transformed into great works of art. As an artist, you need to develop a heightened awareness of the patterned designs that are available in the world around you. Be a pioneer, constantly on the lookout for opportunities in which to document these patterns in your journal or sketchbook.

Experiment with wax relief, pen and ink, photography, mixed media and other media to reproduce or invent a unique inventory of patterns that can then be used to create your masterpiece.

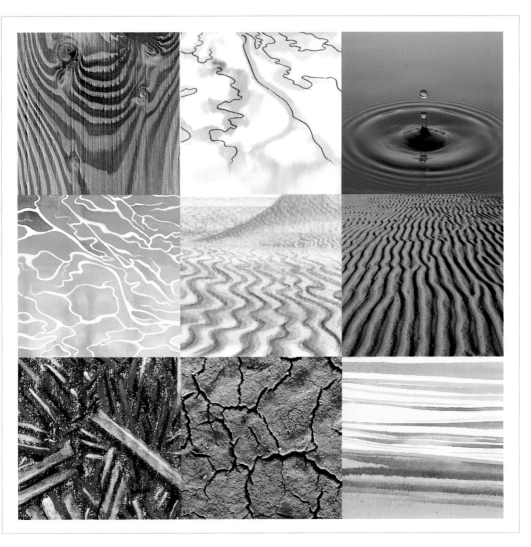

Variations on a theme

Two artists will depict the same subject in very different ways. We call it their "style", but it's basically determined by the kind of linework and marks that an artist prefers to use in sketches, drawings and underpaintings.

Each time you approach a subject, consider its essential nature and how best to convey it. Decide on the type of lines and marks you wish to use. This choice will be determined partly by the way you like to work, and partly by your choice of medium. Depending on how you use it, however, the same medium can create dramatically varied results. Explore these effects with lots of experimental sketches before you start.

31 Have a draw off!

Identify your preferred style of line through a series of disciplined exercises. Look at the two drawings of a family of parrots (right). Sketch the same subject several times, incorporating different varieties of line each time. As you focus your viewer's attention, and establish points of interest, your handling of line will be one clue to your overall stylistic preference. For example, you could set the scene using high-definition lines against a richly crosshatched background. Now draw the subject once more, completing the composition using fine lines against a solid backdrop instead.

Test your draughtsmanship skills by sketching the same harbour scene (right) in two different styles. Look at how the two individual artists have tackled the same setting. Let your linework capture the unique flavour of this small, Mediterranean waterfront. Not just the chosen strokes, but also your choice in the placement of key elements will determine the look of your work. A graphic approach, for example, will incorporate sharper strokes and contrasting tones. A more painterly approach will reflect atmosphere with a softer handling of the composition using midtones and looser lines.

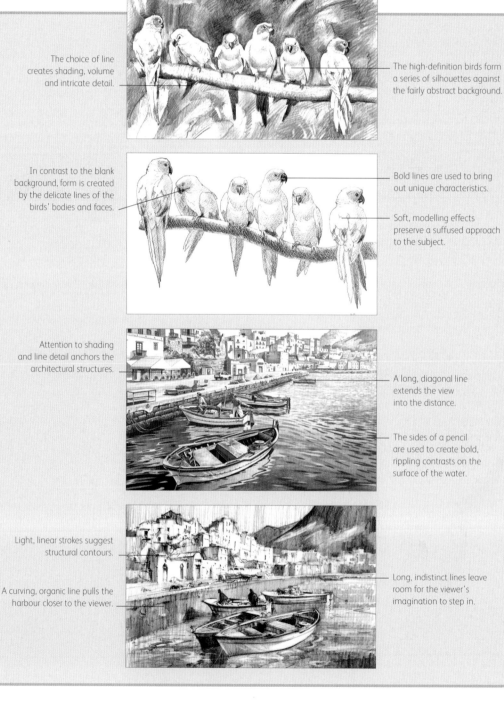

The choice of line creates shading, volume and intricate detail.

The high-definition birds form a series of silhouettes against the fairly abstract background.

In contrast to the blank background, form is created by the delicate lines of the birds' bodies and faces.

Bold lines are used to bring out unique characteristics.

Soft, modelling effects preserve a suffused approach to the subject.

Attention to shading and line detail anchors the architectural structures.

A long, diagonal line extends the view into the distance.

The sides of a pencil are used to create bold, rippling contrasts on the surface of the water.

Light, linear strokes suggest structural contours.

A curving, organic line pulls the harbour closer to the viewer.

Long, indistinct lines leave room for the viewer's imagination to step in.

32 Now try using colour

Another timeless classic that continues to inspire artists the world over is the floral landscape (right). All of the Impressionists loved to paint flower gardens, but each artist had his individual style. How do you go about creating your unique vision of a garden scene? Remember that you just experimented with various approaches using pencil and other black-and-white media on page 24. Do the same here, but this time use colours in a variety of media to test your stylistic skills. Start with the same subject for both compositions, and then change the linear quality of each significantly to produce very different end results. Don't forget to have fun with your linework. Experiment with quality of line, tone and value, crosshatching and the manipulation of shapes. Use coloured pencils for both drawings.

The still life is another classic subject as it provides ample opportunity to practice and develop technique. Begin with a pencil sketch of the basic composition and background elements in this traditional still life of pears (right). Repeat, this time making sure that you manipulate line, texture and shape differently. Decide whether you will indicate the changes in tone with hard lines as in the first example, or with softly graduated shading as in the second.

The house in the background creates a linear outline that helps to emphasise the various flower shapes in the foreground.

Strong lines are combined with white spaces and transparent colours to allow light to filter through.

The outer edges of the flowers are outlined and defined using pigments mixed on paper.

The simplified background helps push the floral garden forward.

The colours used are layered through several value gradations.

The petals are opaque and set against a crosshatched backdrop.

Line patterns add interest and direct the eye of the viewer.

The textured lines of the wood-grain background are simplified, allowing the stark, bold line of the panel to frame the pears.

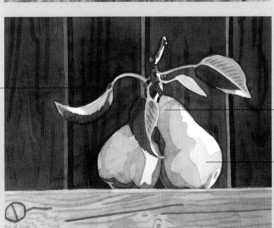

Successive hard-edged layers of fresh greens describe the progression from light to shade.

Volume is expressed through transparent colour and line modelling.

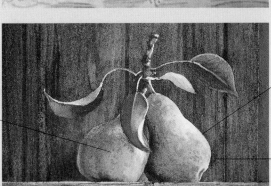

Texture and shading created by stippled paint marks convey the "feel" of the fruit's surface.

The contour lines of the pears are enhanced against the textured surface of the background.

Slight variations in colour separate the shelf from the backdrop.

This version uses a limited, four-colour palette of Winsor blue, Venetian red, lemon yellow and manganese blue.

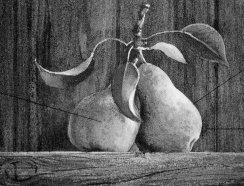

Creating images around an idea

Instead of drawing from reality, you will sometimes need to imagine the kinds of images that you want to create. They might be fantastical or based on an event or story, which requires doing some research. Your drawing skills will come in handy, both for documenting your research and creating the final drawing or painting.

Imagine you've been asked to create a mural in a public or corporate space, for example. The history of the place and background to the message are good starting points. Alternatively, you might be commissioned to illustrate a children's storybook or a CD cover, in which case knowing how to interpret and research a brief will prove essential.

33 Novel approaches

Choose two passages from a book that evoke strong images in your mind. Do some research on them. Search the Internet, look in old magazines, newspapers and archives, or watch old movies. Is a specific location needed? Is the setting historical, contemporary or futuristic? What would the characters be wearing and doing?

Extracts from Graham Greene's *Brighton Rock* (1938) required research of gangster life in a 1930s British seaside town. The illustrations on the left and right show the artist researched the clothing and cars of the time from photographs (below).

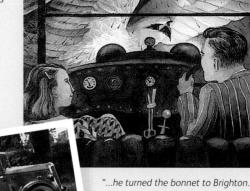

"The surprise at first was far worse than the pain (a nettle could sting as badly)...They grinned back at him: every man had his razor out..."

"...he turned the bonnet to Brighton. An enormous emotion beat on him; it was like something trying to get in; the pressure of gigantic wings..."

34 The zodiac

There are dozens of different ways of interpreting the twelve signs of the zodiac. Look at the different interpretations that illustrators give these symbols in magazines, books and newspapers. Create your own zodiac sign using the symbols below as a reference.

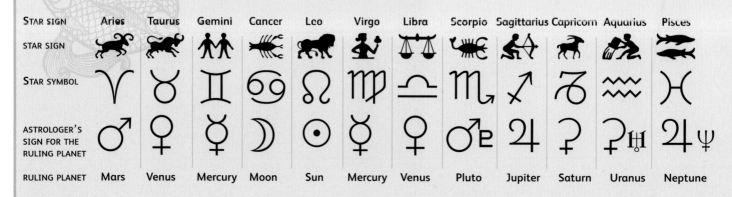

STAR SIGN	Aries	Taurus	Gemini	Cancer	Leo	Virgo	Libra	Scorpio	Sagittarius	Capricorn	Aquarius	Pisces
STAR SIGN												
STAR SYMBOL												
ASTROLOGER'S SIGN FOR THE RULING PLANET												
RULING PLANET	Mars	Venus	Mercury	Moon	Sun	Mercury	Venus	Pluto	Jupiter	Saturn	Uranus	Neptune

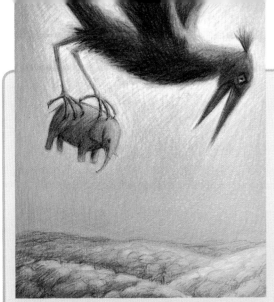

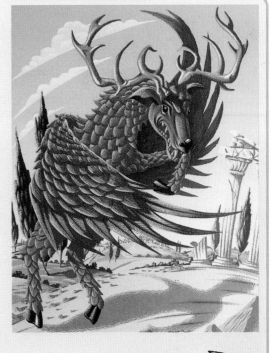

These three extracts from fantasy texts contain detailed descriptions of fantastical creatures. Use them as starting points for your own vision.

"Known as the King of Gigantic Birds, the Roc (left) is so vast in size that it darkens the earth with its flight, like a cloud covering the sun. This monster has been sighted from Madagascar to the China Seas. Sailors say it can carry off a ship in its beak."

35 Illustrating a story

If using fantasy or mythology as the basis for your art, don't be afraid to unleash your imagination. Think about the impact of choice of colour, composition and markmaking on the story you are trying to tell. Consider how the image of the gigantic bird (above) enhances the accompanying quotation. Do the same for the other two passages and images. Choose some fantasy writing and create the creature being described by the author.

"The Peryton (right) has the antlered head and legs of a deer, and the wings and body of a bird. A mortal enemy of humans, it casts the shadow of a man until it kills its first human victim, at which point its real shape is reflected in its shadow. It can kill only one man in its lifetime. Perytons lived in Atlantis until an earthquake shattered this mysterious civilisation. The Perytons escaped into the air during the disaster, and were later sighted flying high above the Pillars of Hercules in great flocks."

"Taking care of newly hatched dragons (below): watch the shell for signs of cracking and the appearance of a tongue or claw. It will take up to twenty-four hours for the shiny baby dragon to work its way out of its shell. Most dragons take well to going walking when only a few days old, though you may have to keep it on a leash until properly trained."

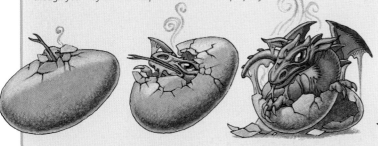

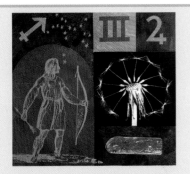

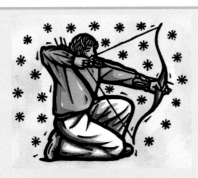

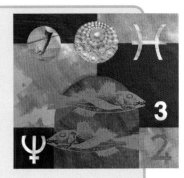

These two versions of Sagittarius (above and right) and Pisces (far right) show you how to create your own astrological piece of art. Use either collage with a painted background or black waterproof ink painted in with a fat line brush and several watercolour washes. Research a sign's associated character traits or birthstone for an added dimension.

Abstract concepts and symbols

Everyone is familiar with abstract ideas and symbols. Throughout history, artists have developed their own symbols as clues to meaning in their paintings. Let us now examine a few examples where such concepts have been incorporated into art. We will also explore unique and universal symbols, why they are important and how you can design your own.

Since the dawn of civilisation, cultures, religions and societies have used symbols to communicate, trade and govern. The early Christians used iconography and illuminated manuscripts to teach their religion. In Jewish culture, Hebrew words were artworks in themselves through a process known as micrography. Arabic calligraphy blends words into representational imagery to convey its teachings. The Surrealists used objects from dreams to explore the subconscious. Abstract Expressionists such as Jackson Pollock removed all recognisable symbols from the painting process.

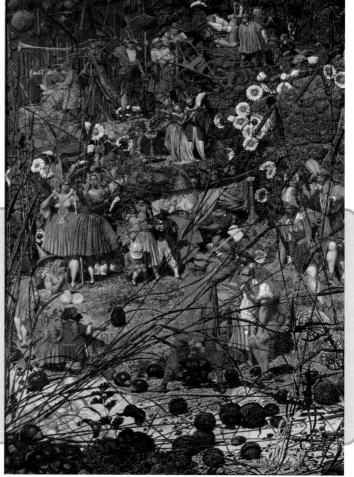

36 World within a world

Painted by Victorian painter Richard Dadd, *The Fairy Feller's Master Stroke* (1855–64) is a charmingly surreal composition. A fairy lumberjack is about to break open an acorn with an axe to make a carriage for the fairy queen. Everywhere you look, he is surrounded by fantastical creatures. The painting vividly tells a story extracted from the imagination of the artist. Although the core concept is abstract, with the creatures a product of Dadd's powerful subconscious, images symbolic of more familiar ideas are also recognisable. This work has been used on book and CD covers. Use your imagination to create your own fantasy world.

37 Drip, dribble or splash it!

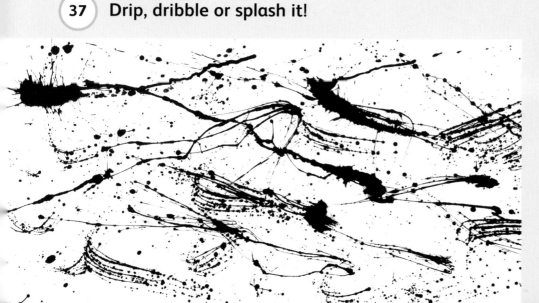

Influenced by Native-American sand paintings, Jackson Pollock created abstract paintings in the late 1940s that changed the way artists looked at art. For him, it was more about the process than the finished product. Nicknamed "Jack the Dripper", he would dance around his canvases, dripping and splattering paint with large brushes and sticks to create large-scale, abstract works.

Cover the floor of your garage with butcher paper or a large canvas. Turn on some music. Move around the artwork, creating shapes inspired by your movements. Give your work a two-word title or a number à la Pollock.

38) Seeing things in a new light

Choose a collection of ordinary objects such as the watercolour pans shown below to render in a variety of media. Use your hands to "frame" your composition. Paint the pans in several different colours. Look at the finished painting through the "frame". Now focus on painting one single pan, but at a much bigger size, so that it no longer is recognisable because the change in scale has rendered it abstract. Alternatively, paint an object of your choice upside down, on its side or select a small detail.

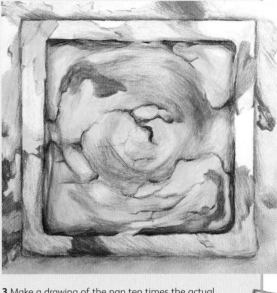

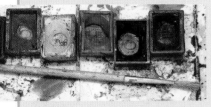

1 Choose a group of small objects, such as this collection of watercolour pans, as a reference or starting point.

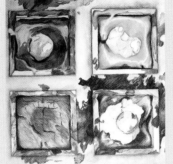

2 Draw a selection of pans using coloured pencils. Make the objects five times their actual size so they become little compartments within a bigger composition.

3 Make a drawing of the pan ten times the actual size! Observe how such a drastic change in scale decontextualises the object.

39) Collect it: symbols in daily life

Cultures and societies create symbols to share information within a community. In ancient times, symbols were used to document inventories, identify powerful social and political figures, authorise documents, protect religious groups from persecution and show prestige. In the modern world, symbols and signs guide us through traffic, communicate humour and remind us of rules that help us to live together better. In the world of business, popular brands are recognisable symbols and big money.

Universal or global symbols inform us of danger, rules and regulations and teach us how to be good, law-abiding citizens. Try to interpret some of the symbols shown on the grid (right). Make an inventory of symbols that you see in the everyday world. Study the logos and branding of your favourite products, then try to create your own. Perhaps start with a drawing of your initials. Your aim is to create a memorable design that people will remember. Transfer your logo or symbol to a business card and create your own customised stationery.

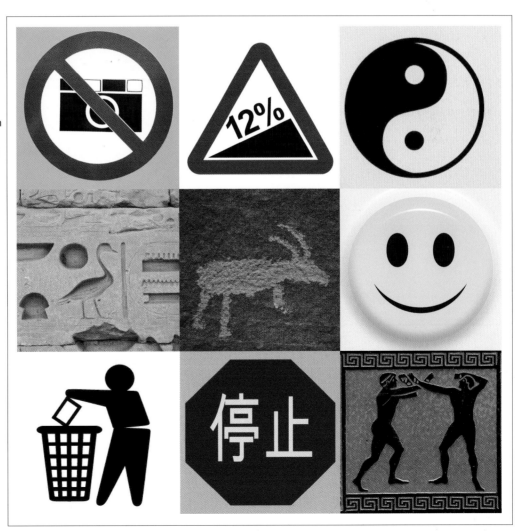

Op, magic and kinetic art

41

This type of art uses geometric patterns and optical illusions to provoke physical and psychological reactions in the viewer.

Popular in the 1950s and 1960s, Op (Optical) Art and Kinetic Art reflect the era's interest in experimental designs and in expanding the boundaries of cognition. An ordered yet chaotic arrangement of lines and shapes creates the wavy patterns and odd perspectives that result in a kinetic connection. Magic Art, another popular type of kinetic art, also relies on optical patterns and illusion.

Magic eye

This 3D craze requires viewers to look "through" the 2D surface pattern to the hidden 3D illusion embedded within. Try drawing or digitally creating two different line patterns on a horizontal plane. Make sure each line is slightly different from the others. Now turn one of the drawings upside down, attach the two together and look at them stereoscopically. What do you see?

40 Kinetic cityscape

Victor Vasarely, one of the fathers of Kinetic Art, was commissioned to create the Olympic Games logo in 1972. One of his unfulfilled dreams was to design a whole city in the style of Op Art. To inspire your own urban design (below), take photographs of buildings or constructions around your hometown or neighbourhood. Prepare a photographic montage and make a sketch of it. Colour it in with markers.

42 Vibrational patterns

Curvilinear lines placed close together create a kinetic or electrifying effect that literally causes your optical nerve to vibrate. Look at the pattern on the right. Doesn't it seem to move? Creating your own piece of Op Art can be difficult and requires patience. Start with a pencil sketch that you then need to ink. Remember that a dramatic effect requires intense contrasts. Rather than trying to create the entire composition all at once, take it in stages, one step at a time. Work up one section at a time, and cover up those areas of the composition that you are not working on with soft construction paper.

43 Virtual gallery

Think Quest Enter an interactive world of optical illusions.
http://www.thinkquest.org/library/site.html?team_id=C0111882

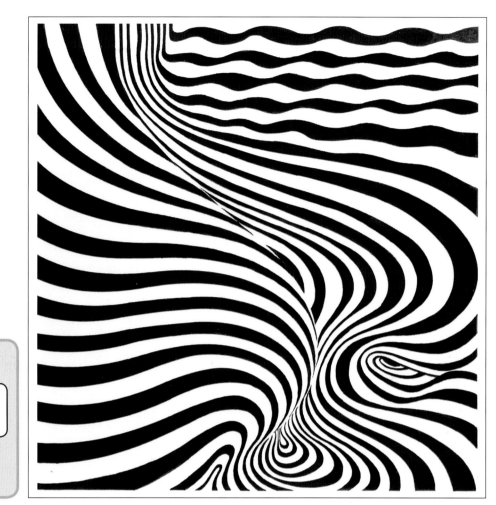

A balancing act

A sense of balance helps the artist successfully negotiate the challenges of the compositional tightrope.

A good composition stops a viewer in his tracks. Once you have his attention, you can reel him in, guide him around your work and, above all, keep him interested. The art of creating the perfect composition has preoccupied artists for centuries. Back in the days of the Renaissance, artists used the "Golden Section", a rather complex mathematical theory based on current notions of ideal proportion as a geometrical framework for perfectly balanced compositions. Although the approach to composition is much more relaxed and intuitive nowadays, balance remains key. Below are some of the core compositional approaches worth bearing in mind as you design your pictures.

44

Compositional maps

Renaissance master Leonardo da Vinci was a genius of composition. Learn more about balance from other Old Masters such as Giotto, Titian and Raphael. See if you can spot the underlying compositional "map" that directs the onlooker to the main feature of each painting.

In *The Adoration of the Magi* (1481) (right), Leonardo positioned the key figures inside a "triangle" with the head of the Virgin at its apex. She is surrounded by space and the other figures lean in towards her, drawing the eye to the focal point of the painting.

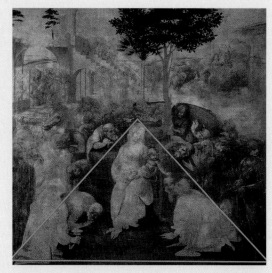

45 The telling triangle

As a naturally dynamic shape that you can tilt any way you want, a triangle is a great starting point for arranging effective compositions. Set it on its base for a stable and grounded composition or on a point for a more energetic image.

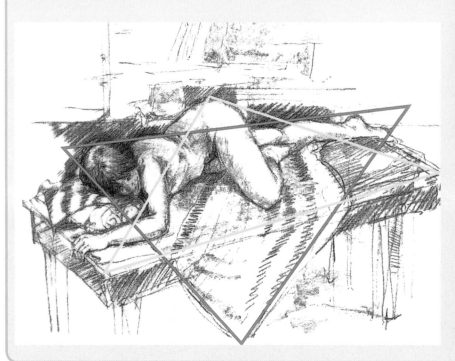

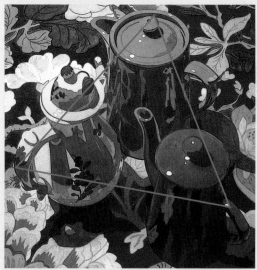

A high viewpoint and triangular composition make this watercolour of coffeepots (above) an arresting, intense image. The eye of the viewer is constantly kept on the move, from one edge of the triangle to the next point, as it takes in each object in turn. The invisible triangle holds the group together and stops the eye getting lost in this richly patterned painting.

You can incorporate more than one triangle into a composition. An inverted triangle (left) interacting with a basic triangle adds extra interest and dynamism to this arrangement.

46 Three, the magic number

Three is a naturally balanced number. To help you organise your composition better, imagine your picture plane divided into thirds – horizontally, vertically or both. Avoid crowding everything into the centre. Instead, place key elements in the outer areas and give the eye room to move around the scene.

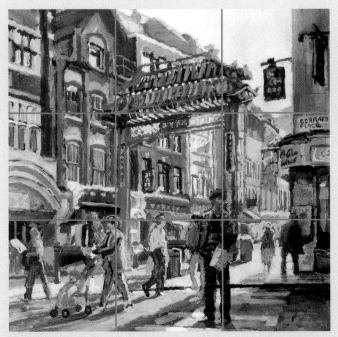

This colourful and energetic scene subtly uses the rule of thirds. The two main figures and the Chinese gateway are positioned on vertical thirds. Although in perspective, the buildings relate to the horizontal grid, the gateway roof at the top, and the shopfronts on the lower grid line.

47 The magic circle

A circle creates a sense of balance and movement in a composition. It draws the attention to the focal point in a picture and keeps the eye constantly moving around it. You can include an actual round object in your subject, or place key elements in a circular arrangement to focus the viewer's attention where you want it most.

In this energetic image (right), the eye is guided first to the white disc of the plate, then to the echoing circle of the place mat underneath. The viewer's gaze spins around to the vibrant orange blossoms, taking in the balancing verticals of the brushes, and is then immediately drawn back to the whirling vortex of the plate, and on around to repeat the journey.

Balancing colour 48

Colour isn't just a powerful mood generator. It's also a vital tool in your compositional kit. You can use colour placement to create balance, move the eye around with areas of echoed colour and exploit the effects of complementary colours to create focus. Take a look at your favourite paintings and see how other artists compose with colour to produce harmonious images that grab the viewer's attention.

Warm/cool and complementary colour contrasts (warm yellows and oranges for the sky and cool blues and purples for the snowy foreground) balance this composition. The artist uses an acrylic underpainting and thickly applies pastel over it. Touches of cool purple (sky) and warm blue (snow) link the two halves of the scene.

Tricks of the composition trade

Composition isn't just about rules, rules and more rules. There are also plenty of nifty devices and tools that make an artist's job a lot easier.

Over the centuries, artists have invented clever, user-friendly devices as stepping stones to creating great works. Future artists will no doubt benefit from the latest hi-tech developments, in the same way that many art inventions from the past still have relevance today. If you like taking photographs, you'll be familiar with the notion of a viewfinder, a "window" in the camera that you look through to frame your subject before clicking the shutter. Without it, great pictures would not be possible. Artists use a similar device to help frame their subject and a basic grid to help place the elements making up a composition. Proportions can be measured accurately without the need for clever machinery through shortcuts that are simple to use and work. They don't constitute cheating so don't be afraid to try them!

Making a viewfinder 49

It's easy to construct a totally adjustable and completely portable viewfinder. You can use it whenever you need to make the compositional decisions that are an essential part of producing good art.

1 You will need two L-shaped brackets that are 76 cm (3 in) wide and 25–30 cm (10–12 in) long. Make sure the corners are perfect right angles. Use stiff dark grey or black cardstock that won't distract your eye from the subject.

2 Place your L shapes together, so they form a rectangular window that frames your subject. You can hold them together with masking tape or bulldog clips.

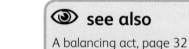

👁 **see also**

A balancing act, page 32

50 More than a pencil

The secret to drawing anything convincingly is getting the proportions right. This is true of whether you're drawing buildings, landscapes, still-life subjects or the human figure. If you guess point-blank, chances are you'll get it wrong, as even experienced artists often need help with getting the measurements right. What's required is a quick way of measuring and checking proportions and relative sizes. Here's a simple trick for doing just that, using a pencil as a measuring tool.

1 Hold the pencil out at arm's length, close one eye, and line it up with whatever you want to measure (in this case, the back of the chair). Slide your thumb down the pencil shaft to take the measurement.

51 Being framed

Use your cardstock L's to make an opening that is adjustable to any format and size that you want, from the classic square to variations on a portrait or landscape theme. Your viewfinder will help you to select a pleasing composition for landscapes, interiors, still lifes and figure studies. Use it to explore the compositional possibilities in photos or to help you select elements for a quick sketch that you can then develop into a finished piece.

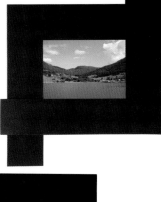

1 This landscape format includes large areas of sky and sea for the eye to explore.

2 Crop the photo using a narrow landscape format. This kind of frame gives maximum importance to the landscape, with just slivers of sky and sea to frame it. Quite a difference!

Viewfinders and the "rule of thirds"

Create attention-grabbing compositions quickly and easily with the "rule of thirds". Divide your picture area into three horizontal and three vertical segments (picture the grid in your head or sketch it lightly on paper). Use the lines in each direction to create a dynamic asymmetrical composition (much more exciting than a boring symmetrical arrangement)!

Apply the "rule of thirds" with the help of your viewfinder. With a black marker and a ruler, divide two acetate sheets into three equal columns. Line them up to form a grid of nine equal rectangles. Clip them together between your two L-shaped brackets and you've got an instant see-through grid.

1 Hold the viewfinder grid out at arm's length, close one eye and look at your subject through the window. Move the frame around until you find an interesting and balanced composition.

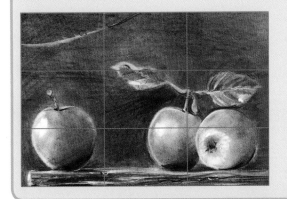

2 In this drawing, the viewfinder helps create a balanced composition using the "rule of thirds". The apples are placed in the outer thirds of the frame, leaving the centre empty, so that the eye is compelled to keep on moving from one apple to another. If the pieces of fruit were centrally placed, the piece would look far more static and dull.

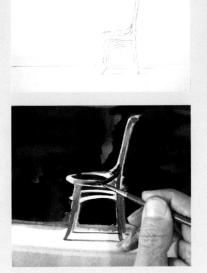

2 Keeping your thumb in place, transfer the measurement and put the pencil down on the paper. In this way, objects will be captured at the scale at which you are viewing them. Compare proportions (for example, the height of the back of the chair against the leg length). Apply this information to your drawing. Use your pencil to check the angles of objects. Notice the chair back isn't perfectly straight, so hold out the pencil and align it with the back to check the slant. Keep re-checking to make sure you're getting it right.

3 Paint your sketch.

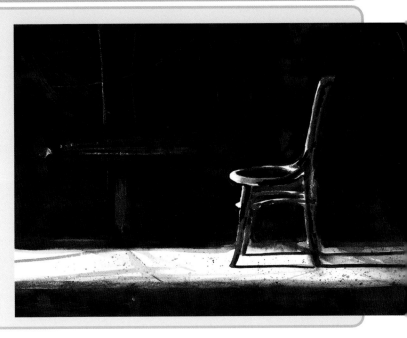

Get the sketchbook habit

Your sketchbook is your own private place for collecting visual notes and creative doodles, however wild or crazy, and for experimenting freely with all of your artistic ideas.

When applying for art school, your sketchbook is a vital tool for showcasing your creative thought processes. Probably the most important item in your portfolio, the sketchbook is a place (and a space) to think, flex your artistic muscle and experiment with linework, markmaking, colour, shape and composition. Practise your artistic skills. The more you doodle,

53 Sketchbooks are for sketching, cutting, pasting...

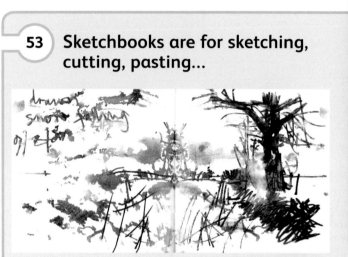

...quick visual note-taking and Rorschach-style water and inkblots...

...musings, doodles, whimsical flights of fancy and private thoughts...

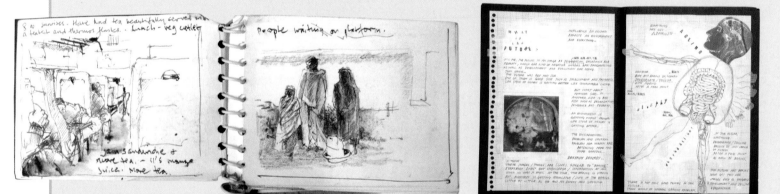

...record keeping, travel writing and fragment sketching...

...gathering research and documentation...

...cherishing private observations and personal reflections...

...experimenting with markmaking and different media...

the better and more confident you'll become. Experiment with new ideas. They can be as spontaneous or as wacky as you like. Copy professional artists and designers. Their studios are lined with shelves of sketchbooks and visual notes collected over years.

Nervous about sketching people?

Try drawing a friend in a car. No one will expect your sketching to be accurate, but it's fun and makes the journey go more quickly.

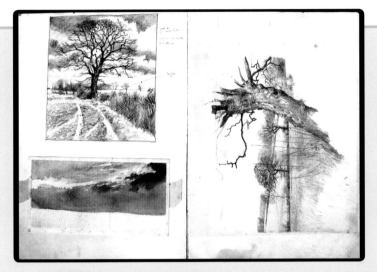

...making detailed observational drawings in preparation for painting...

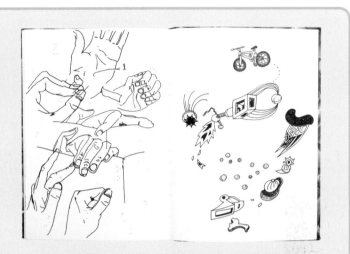

...experimenting with different viewpoints and objects...

...playing with coloured, pierced page layers...

...collecting photographs, silhouettes, opaque pages and collages...

...documenting experiments with texture and patterns...

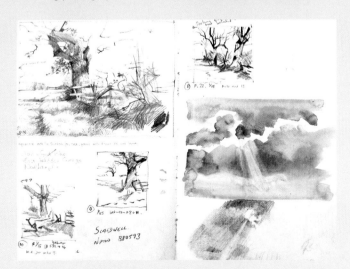

...recording trees, sunlight and cloud formations...

MODULE

2

Colour and tone

"Colour is my day-long obsession, joy and torment." **HENRI MATISSE**

What grabs your attention most in a good painting? Is it the vibrant or moody colours? Is it

perhaps the exciting use of tone in lights and darks? Colour and tone work hand in hand, so it is

likely to be both. In Module 2, you will find out how to combine and use these two elements to

create convincing and atmospheric works of art.

Colours, pigments and the colour wheel

Pigment mixed with liquids or binders creates fabulous colours. Learning to use colour is part of becoming a skilled artist, which is where that useful device, the colour wheel, comes in.

Colour wheels may seem dull and theoretical but the concept behind them is hugely important to art. These vital tools help artists organise, plan and compose successful works. As the best example of a chromatic spectrum, this type of colour chart excludes white and black because all colours in the spectrum create white light and the absence of light is represented by black. Use a colour wheel to create your initial palette before adding more colours onto it. To create a colour wheel, start with three basic hues known as primary colours (red, yellow and blue). Mix them together to create secondary colours: red and yellow make orange; red and blue produce violet; a mixture of yellow and blue brings out green. The remainder of the colours on the wheel are intermediates or tertiary hues.

see also
Cool and warm colours, pages 42–45

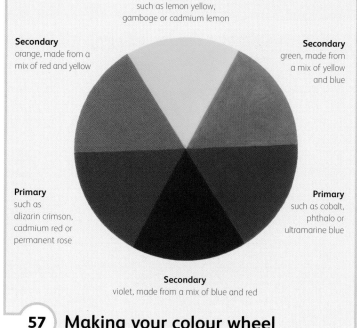

Primary
such as lemon yellow, gamboge or cadmium lemon

Secondary
orange, made from a mix of red and yellow

Secondary
green, made from a mix of yellow and blue

Primary
such as alizarin crimson, cadmium red or permanent rose

Primary
such as cobalt, phthalo or ultramarine blue

Secondary
violet, made from a mix of blue and red

57) Making your colour wheel

When preparing your own colour wheel, remember that it all starts with red, yellow and blue. Mix the secondary colours so they are as similar as possible to those shown on the wheel above. Draw a circle about the size of a small pizza box on a piece of cardstock or poster board. Divide it into six "slice" sections. Yellow should be at the top and purple (violet) at the bottom. Starting on the right-hand side, create the following sections in a clockwise direction: yellow (top of the wheel), green, blue, purple (bottom of the wheel). Continue with red and end with orange. Although you can buy these secondary colours as ready-made pigments, it is good to know how to mix your own.

55

Virtual gallery

The World's Finest Guide to Watercolour Painting The importance of colour pigments for all artists, not just watercolourists. http://www.handprint.com/HP/WCL/water.html

56) Creating colour charts

Combining different pigments is one part artistic know-how, one part chromatic wizardry. Although you can buy ready-made green paint, mixing colours is more fun. Some pigments are so powerful that it may only take a dab to create the desired result. Prepare a colour chart (see Jan Hart's, right) by mixing a series of yellows and oranges with blues. After combining one colour, add a small amount of another pigment and see how the value changes. For darker intensities, add oranges to blues. Note down the mixing formulas or recipes for each magical colour combination.

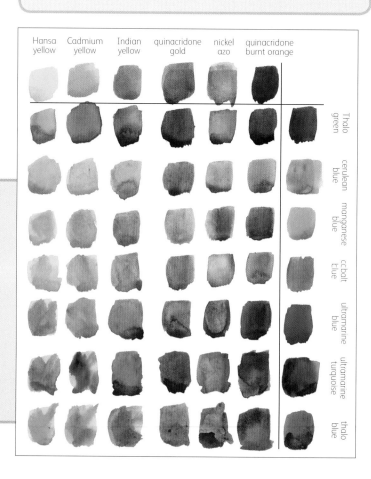

Hansa yellow	Cadmium yellow	Indian yellow	quinacridone gold	nickel azo	quinacridone burnt orange

Thalo green
cerulean blue
manganese blue
cobalt blue
ultramarine blue
ultramarine turquoise
thalo blue

The remarkable six-colour palette painting

58

Even the most mundane objects can become exciting works of art with a little colour magic added to the mix. Identify the colours used and mixed in this painting (right). Look at the hues flowing out of the mugs, mixing and blending into new colours. Titanium white and cerulean blue are used for the soapy suds. Permanent green light spreads into the water. Cadmium yellow with a speck of green spills out of the tumbler and into the plate. The coloured dots create pretty patterns. Cadmium red highlights bring the stripes of the cups to life and spread out to blend with the yellow. Framed by the lilac cup, the goldfish, a mix of alizarin crimson and cerulean blue, forms an element of surprise as a painting-within-a-painting.

Can you see?
Permanent green light
Titanium white
Cerulean blue
Cadmium yellow
Cadmium red
Alizarin crimson

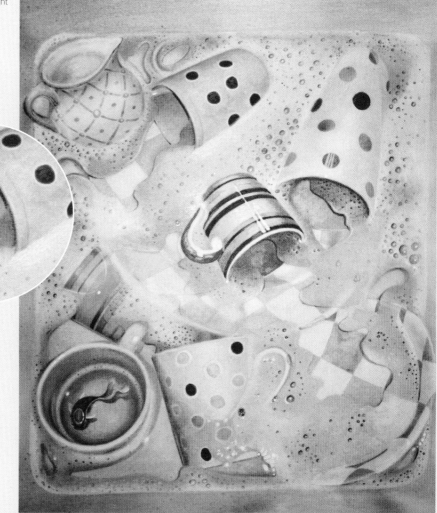

Create your own six-colour palette painting. Use some colours straight from the tube. Mix the rest.

59 ## Harmonising colours

Analogous colours can be found adjacent to one another on a colour wheel. This painting of marigolds (right) uses cadmium orange and yellow Naples. Cobalt violet is a complementary colour and mixtures of it are used for the background to add extra interest to the composition.

1 Use a fine paintbrush to establish detail and build up the transparent layers.

2 A palette knife is useful for lifting out highlights and adding in the final touches.

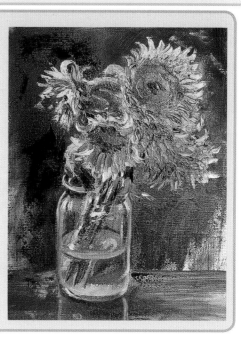

Cool colours

The chromatic properties of green, blue and violet make them natural candidates for cool colour palettes.

You will find these kinds of colours in objects that are naturally cool: green trees and foliage, blue water and sky, violet cloud formations and the ocean. In art compositions, cool colours tend to recede into the background to create a calm, quiet, moody effect. Pablo Picasso appreciated the power of blue. During his well-known Blue Period (1901–04), he produced heartfelt, mournfully expressive paintings in a variety of blues. His *Femme aux Bras Croisés* (1901–02) is a fine example of this phase in Picasso's career.

60 Cool colour palettes

Artists often determine their palettes before beginning a work of art. Picasso predominantly used one-colour schemes for his Blue Period works. Beginners should start with a limited palette of only two to four colours before adding more. Notice how the blue tendency in the green, yellow and crimson below make them "cool" versions of these colours.

Cerulean blue	Phthalo blue	Violet
Viridian	Lemon yellow	Alizarin crimson

61 Virtual gallery

Degraeve Colour Palette Generator
A fun online tool but no substitute for creating your own palette.
http://www.degraeve.com/colour-palette/index.php.

62 The impact of the unexpected

Create a blue painting in the style of Picasso's Blue Period. Select a human subject and use variations of blue and purple to convey the sitter.

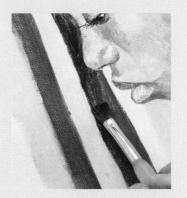

1 Using a limited colour palette, blend in two cool complementary colours to get a deep grey tone.

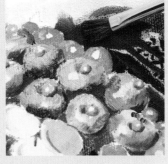

2 Use variations of blues, greens and violets for the shadow areas and headpiece details.

3 Picasso used models for his paintings. Although traditionally you would expect this African-American subject to be portrayed in warm, earthy colours, the use of a cool palette provides an element of surprise. Cool tones can be used for intense emotions, such as isolation, but also help define expressive faces.

63 Landscape in cool and warm colours

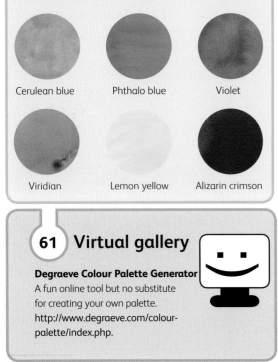

Working from this photograph (above), create a composition in blues, greens and violets. Now try it in reds, yellows and oranges. Study the resulting mood and the way in which certain colours recede while others advance. Observe how the French Impressionist painter Claude Monet captured colour changes at different times of the day in his landscape series.

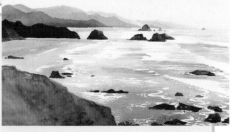

Morning scene painted in blues, greens and violets. Notice how the cool tones tend to recede into the background.

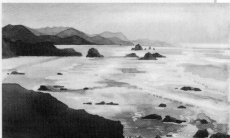

Sunset scene painted in oranges, yellows and browns. Notice how the warm tones tend to advance into the foreground.

64 Blue effects

Use the camera on your mobile phone to take a snapshot of an everyday object that is normally red, such as a strawberry. E-mail it to yourself. Import the image into a software paint programme and experiment with value, intensity, contrast and hue, using colour balance, brightness/contrast and shadow/highlight tools. Observe how this treatment affects the look, meaning and mood of the object.

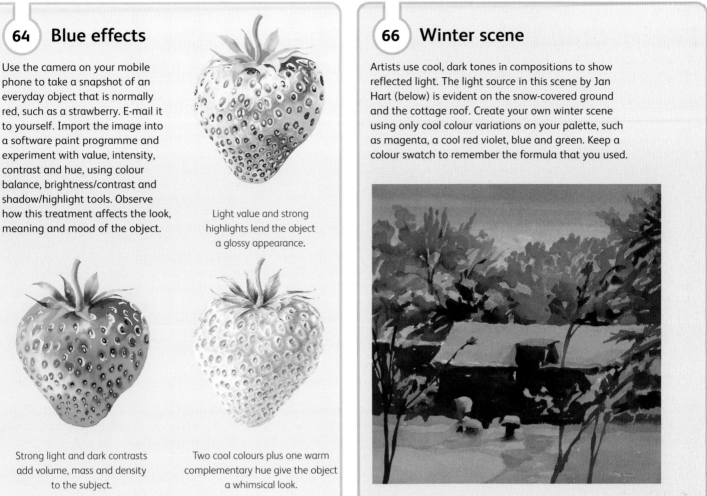

Light value and strong highlights lend the object a glossy appearance.

Strong light and dark contrasts add volume, mass and density to the subject.

Two cool colours plus one warm complementary hue give the object a whimsical look.

66 Winter scene

Artists use cool, dark tones in compositions to show reflected light. The light source in this scene by Jan Hart (below) is evident on the snow-covered ground and the cottage roof. Create your own winter scene using only cool colour variations on your palette, such as magenta, a cool red violet, blue and green. Keep a colour swatch to remember the formula that you used.

65 Using the cool–warm contrast to create a focal point

Use warm colours in a predominantly cool canvas to produce areas of intense visual interest that capture a viewer's attention immediately. Notice how the red dot stands out as the centre of interest among the cool tones all around (right). Create a composition of overlapping letter forms and paint in a palette of cool blues, greens and violets. Give the letter outlines warm edges by dropping in yellow highlights. Finish off your painting with the colour surprise element of having a bright red dot inside the letter "P".

Add texture and movement by creating a cool spattering effect. Simply hold the tip of a loaded brush over your painting and spritz colour off the bristles by flicking them with your fingertip.

Warm colours

Dynamic, bold and welcoming, these pigments capture the viewer's attention and draw him into your art.

Red, yellow and orange are traditionally associated with naturally "warm" or "hot" objects, such as the shining sun, a glowing sunset or a roaring fire. If you walk into a room, a person wearing red will immediately catch your eye and not just because you like their fashion sense. This colour tends to advance towards the viewer, whether in a painting or daily life.

69 **Virtual gallery**

The Life and Art of Giuseppe Arcimboldo 16th-century Italian painter who used fruits and vegetables to create portraits.
www.arcimboldo.art.pl/english/index1.htm
The Bridge at Nantes by Jean Baptiste Camille Corot: Webmuseum Pivotal, 19th-century French landscape painter, etcher and printmaker.
www.ibiblio.org/wm/paint/auth/corot/nantes.jpg
Luncheon of the Boating Party Renoir's celebration of 19th-century leisure on the Seine.
http://www.phillipscollection.org/html/lbp.html

67

Making up a warm colour palette

Cadmium red Cadmium orange Cadmium yellow Cobalt violet Sap green Ultramarine blue

Any warm colour palette will contain a selection of red, yellow and orange pigments (above). In the second tier, you could add in other colours, perhaps those showing a red bias. Ultramarine blue, for example, is the warmest of all blues because it contains an element of red in it. Similarly cobalt violet and sap green include a large amount of red in their composition.

68 **Fantasy playground**

As an artist, you are in control of how your viewer sees and experiences any world you bring to life. Study this scene (*Piranesi* by Tom Kidd, below) and notice how it ties together. One element is colour. Do cool or warm colours dominate the scene? What is the overall tonality? Notice that variations of blues, greens and violets take the viewer through the composition. The warm colours of the architecture seem closer and there is a push–pull tension between warm and cool colours that creates uneasiness. Most figures are clothed in cool hues but there are also splashes of red and other decorative motifs that act as focal points to add interest and movement. Create your own fantasy playground using a basic palette of warm and cool colours.

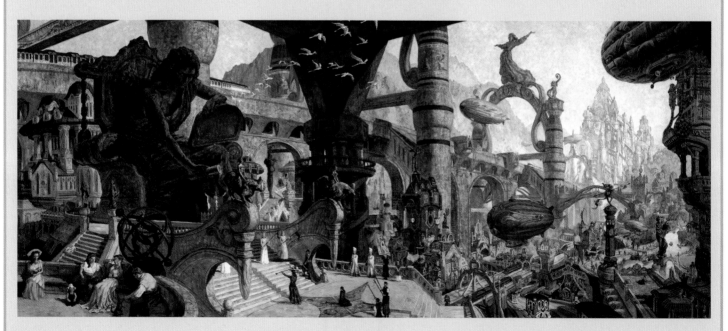

Tickled pink

Surprisingly, reds can be either warm or cool, and any shade of pink or rose tends to be positioned near the blues on the colour wheel as these pigments have touches of blue in them. Practise mixing and blending a wide range of rose-pink colour combinations. Create your own painting using only a selection of warm colours, such as alizarin crimson and quinacridones, as shown below.

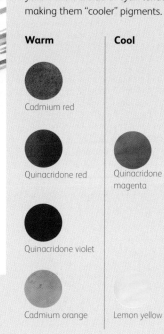

1 Draw a few guide lines in first. Proceed to define the building's general structure by painting in broad areas of colour. Start with the palest tones for the sun-dappled areas. Mix and apply a midtone for the shadows inside the arch. Using a fine brush, start to paint the architectural details. The midtone mix can be used for the details on the sunlit areas.

2 Use quinacridone violet for the darker shadows and window recesses. Allow the white surface to show through as an additional colour. Use a variety of lemon yellow or cadmium orange to place the highlights.

This painting (left) uses a warm–cool palette. All colours in the left-hand column have a warm bias, whereas quinacridone magenta and lemon yellow show a blue or cyan tendency, making them "cooler" pigments.

Warm	**Cool**
Cadmium red	
Quinacridone red	Quinacridone magenta
Quinacridone violet	
Cadmium orange	Lemon yellow

Complementary colours

These are not the pigments that look great on you, but ones opposite each other on the colour wheel.

In human relationships, opposites sometimes do attract. The same is true of colours. Complementary colours appear opposite each other on the colour wheel. These pairs are starkly different from each other, which is what makes them so intriguing. Sparks fly when you place complementary colours together. Combining them creates a sense of agitation, interest and excitement, all of which give energy to a composition.

71 Seeing green?

Fugitive sensation is the optical phenomenon you get when you stare at any colour for a long time, then look at its opposite. Follow the instructions below to see green.

1 Paint a red square. Stare at it for one minute.

2 Look at the white square or stare at a blank piece of paper. Paint what you see. (It should be green.) This will be the exact complement of the red.

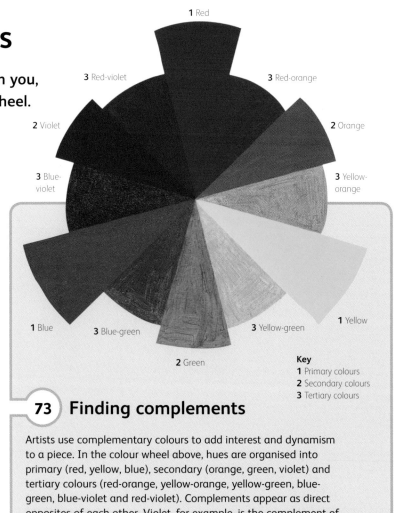

1 Red
3 Red-violet
3 Red-orange
2 Violet
2 Orange
3 Blue-violet
3 Yellow-orange
1 Blue
1 Yellow
3 Blue-green
3 Yellow-green
2 Green

Key
1 Primary colours
2 Secondary colours
3 Tertiary colours

73 Finding complements

Artists use complementary colours to add interest and dynamism to a piece. In the colour wheel above, hues are organised into primary (red, yellow, blue), secondary (orange, green, violet) and tertiary colours (red-orange, yellow-orange, yellow-green, blue-green, blue-violet and red-violet). Complements appear as direct opposites of each other. Violet, for example, is the complement of yellow. The opposite of red is green and orange is the complement of blue. If you paint various colour wheels using different primary colours, you will discover that the relationships between the most vibrant complements do change. The complement of cobalt blue, for example, is orange but it is Venetian red for cerulean blue.

72 A cat called complement

Notice how two colour-wheel complementaries, carbazole violet and aureolin yellow, produce an interesting effect in this simple watercolour by Jan Hart (right). Dark violet is used to create the shadows, while lighter violet values alongside variations of yellow model the contours of the cat's body. The combination of these contrasting colours creates a chromatic tension that works well compositionally.

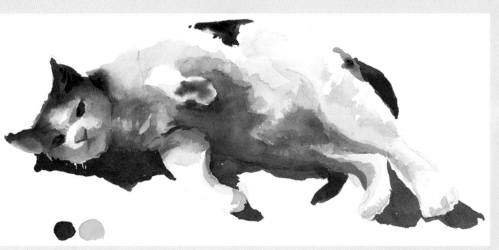

74 Opposites attract

The relationship between complementary colours can be exploited to produce paintings that are strong, expressive and vibrant. Using these colours in the picture plane of a composition immediately intensifies the scene. Observe how the blue, yellow, orange and purple strokes almost appear to vibrate when placed next to one another.

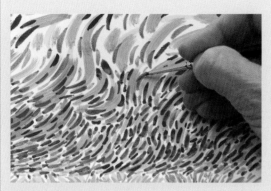

Cadmium yellow Violet

Cadmium orange Cobalt blue

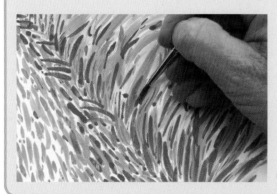

1 In these close-ups, complementary colours are applied in swirling strokes. Violets are painted in alongside yellow with blue and orange thrown in for added effect.

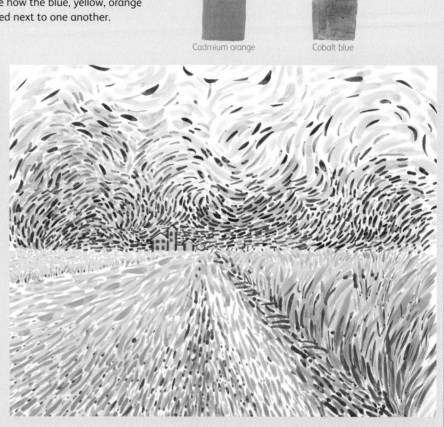

2 Laying down marks in the direction of the stalks helps describe the areas of growing and ploughed corn.

3 The result is a lively, moving and energetic composition. Create your own landscape by limiting your palette to two sets of complementary colours.

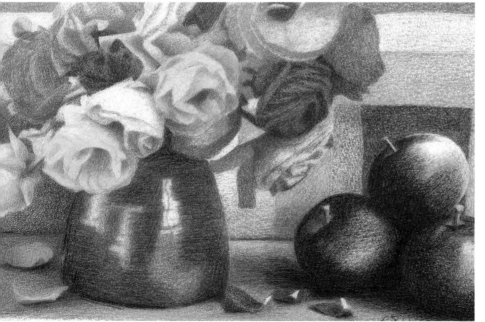

75 Complex complementary painting

Use this still life (left) as a tutorial to challenge your understanding of complementary colours. Rather than relying solely on black and grey, the Impressionists discovered that these colours could also be used for creating shadows. Artists use complementary colours to manipulate the viewer's attention towards details in their compositions. By placing complementary colours side by side, each colour is intensified, becoming bolder and more noticeable. In this painting (left), the complements green and red are used to balance the effects of one another.

Study how the background pattern echoes the overall use of complementary colours. Two sets of patterns are selected. The orange and blue combination is broken with yellow and violet.

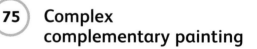

Colour mixing, relationships and intensities

77

Colours do not exist in isolation. What happens to one influences the others.

When it comes to colour properties, you need to think both like an artist and a scientist. When pigments are placed next to one another, the original colour and its decorative qualities will change, some pigments get along better than others and even your choice of paper will influence the end result.

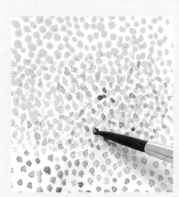

Mixing colours

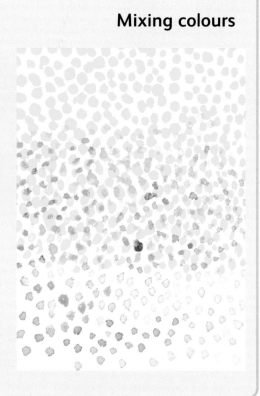

There are different ways of combining colours on paper (right). Artists do it on a painter's palette but also directly onto canvas. The Post-Impressionist artist Georges Seurat placed small colour dots side by side to form a new colour. See how placing a dab of yellow next to an equal-sized dot of blue results in the viewer seeing green from a distance.

76 Seeing blue or green?

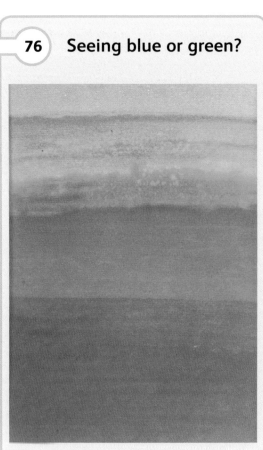

In the 1950s, Color Field painters such as Mark Rothko explored colour relationships and their impact on the viewer. He discovered that the properties of a given colour will change according to the colours surrounding it. Look at the painting above: do you see blue or green? Keep a colour journal and experiment with juxtapositon, mixing and blending.

78 Go dotty

Compose your own Pointillist-style painting using only colour dots or a series of short, sharp marks. Create a busy beach scene in which people are walking, chatting, playing volleyball or sunbathing.

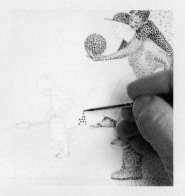

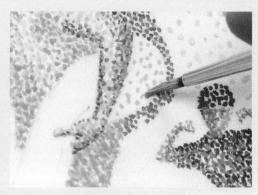

1 Pointillist paintings require patience. Start with an initial pencil sketch to establish the main elements within your composition. Use a small, round brush for more detailed work.

2 Stand back and look at the overall effect before continuing with the close-up aspects. Adjust the size of your brush to correspond to the area you are painting and the distance from which the painting will be viewed. Adjust the colours to include value gradations and broader shading areas.

79 Colour intensity scales

To create a colour scheme that is both harmonious and dynamic, take two complementary colours such as cadmium red and neutral grey and mix them through two separate tonal scales (right). This exercise will create a range of tertiary colours with the mid-point range as a series of greys that can then be modified by adding either black or white.

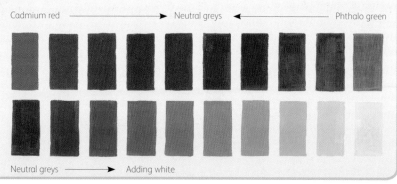

Cadmium red ⟶ Neutral greys ⟵ Phthalo green

Neutral greys ⟶ Adding white

80 Colours in cartoons

Animated cells may be created digitally or by hand. When done by hand, pen and ink and/or cell paints are used. Some software paint or animation programmes use different colour wheels but the same relationships and theories apply. Animators often use traditional oil, acrylic, watercolour and gouache for their background scenes. In this sequence, the complementaries red and green and various of their colour combinations are used to set the mood of the cartoon strip. The character is surprised (1) by a loud knocking (2). Bright red tones depict the villain's fury (3) outside the door. The main character leaves the scene, forfeiting his treasure (4). Create your own sequence.

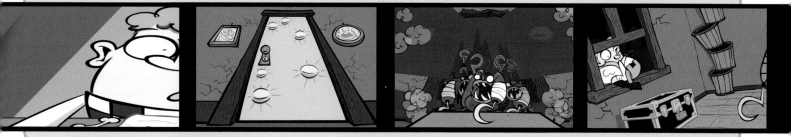

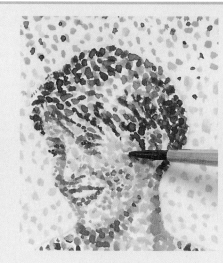

3 As you layer colours to produce finer modelling effects, make sure you don't lose your initial linework.

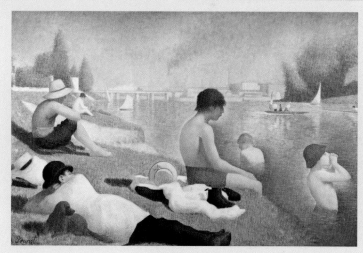

Bathers at Asnières (1884) by Georges Seurat

4 The final result is an interesting textural composition. Compare your final painting with Georges Seurat's *A Sunday on La Grande Jatte* (1884–86).

Defining tone

In painting, tone is similar to keys in music. You have a wide range of keys to work with, and the more variations or notes you use, the more complex the piece will be.

Tone refers to the lightness or darkness of any object. In a black-and-white photograph, it is easy to tell tones apart. The darkest dark is black and the lightest light is white with lots of tones of greys in between. Colours, too, vary in tone. A pale yellow pencil and a dark blue book are different in colour and tone, as the first is light and the second dark. If you change the book to a light blue, however, the colours are different but now the tones are similar.

81 Creating a tonal scale

Every colour has a tonal scale, even black and blue (right). Train your eyes to pick out the different tonal values. Create a nine-swatch scale using black. Add more and more white to each new successive swatch until you reach the lightest tone (white). Now make a nine-swatch tonal scale using blue. Finally use orange (the complement of blue) to create another scale.

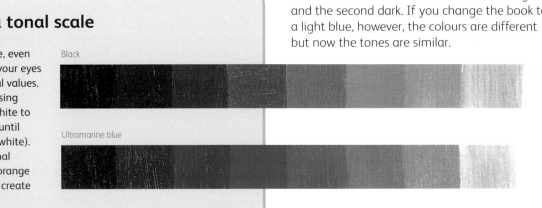

Black White

Ultramarine blue White

82 Using tonal scale in monochromatic painting

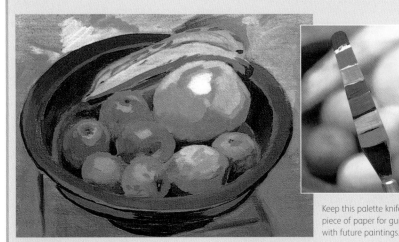

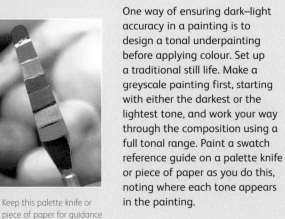

Keep this palette knife or piece of paper for guidance with future paintings.

One way of ensuring dark–light accuracy in a painting is to design a tonal underpainting before applying colour. Set up a traditional still life. Make a greyscale painting first, starting with either the darkest or the lightest tone, and work your way through the composition using a full tonal range. Paint a swatch reference guide on a palette knife or piece of paper as you do this, noting where each tone appears in the painting.

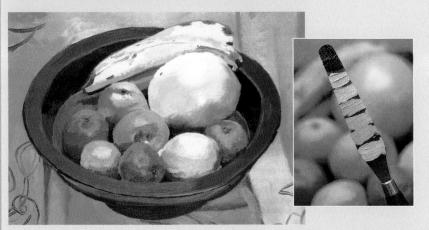

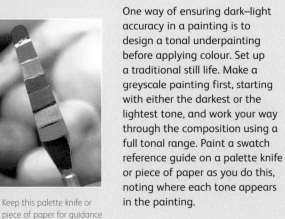

Once you have completed the greyscale painting, take another look at your still life and find the most dominant or key colour. Create a tonal scale based on this pigment. Start with cadmium yellow, repeating the process for green and orange. You may find that less tones are used for the simpler elements.

83 Polychromatic, monochrome and blue tones

Set up a fashion still life using a dainty red slingback as the main subject against a background of red and green polka dots (right). Take a digital photograph of it. Print out a high-quality black-and-white copy to help you find the low- and high-key tones. Use this tonal analysis to create a painting that uses only a range of blues. Notice how the original photograph contains orange tones while the final painting is only composed of cyan tones.

1 Create a tonal scale using phthalo blue, a complement of orange. Use this pigment for the background patterns as well as the main subject.

2 Find the high- and low-key tones in the fine decorative details.

84 Virtual gallery

Essential Vermeer Underpainting was an important stage in Vermeer's work. http://essentialvermeer.20m.com/technique/technique_underpainting.htm
Cézanne's Techniques: Museum of Modern Art, New York Parts of his compositions were first outlined then colour was blocked in using underdrawings. http://www.moma.org/exhibitions/2005/cezannepissarro/conservation/constructing.html

Pale tones

Midtones

85 | Making a collage portrait

1 Grab a stack of magazines and tear them into little pieces. They don't have to be squares. Any shape will do. Sort the scraps into pale tones, midtones and dark tones. This will be your palette.

Dark tones

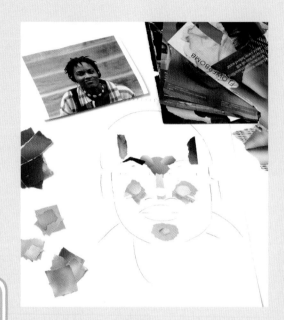

86

Tearing paper in the right way

Believe it or not, there's a real art to this exercise.

1 Tear along the grain and you'll get a nice, neat, straight edge.

2 Rip against the grain and the edge will be ragged with a white edge.

3 When tearing against the grain, achieve more control by holding the paper at the very edge where you are making the tear.

4 Experiment with pulling the paper towards you and away from you to achieve different effects.

2 Find a photograph and draw an outline of the face. Gather your small piles of torn paper and a glue stick. Study the photograph carefully. Where are the highlights (brightest sections) and the dark tones (darkest parts)? Stick the highlights on the cheeks, chin and forehead down first. Glue down one or two dark markers.

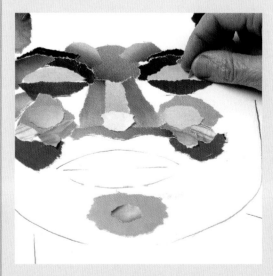

3 Continue to study the photograph. Match the dark and light areas to your paper pieces. Gradually build up the tonal collage, assessing light and dark values as you go.

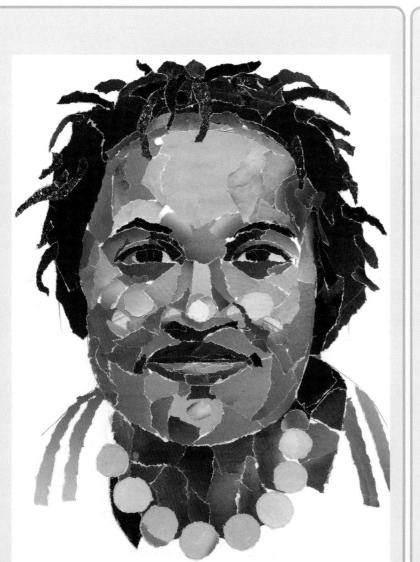

see also

Cool and warm
colours, pages 42–45

4 Colours don't need to faithfully match the way they would in real life, but should be similar in tone. In the finished collage, the artist has used purple for the cool shadows on the forehead and yellow for the highlights on the cheekbones. This produces a more interesting surface effect than if using just a normal range of skin tones.

87 **Virtual gallery**

Eye Contact: Modern American Portrait Drawings from the National Portrait Gallery A rollercoaster ride through the vibrant art of portraiture from the 1880s to the 1980s.
www.npg.si.edu/cexh/eye/index.html

88

Creating a portrait with tracing paper

If you find picking out different tones in colour difficult, try this exercise using black, grey and white to make it easier to tell light, mid- and dark tones apart.

1 Crosshatch some tones on a sheet of tracing paper. Make them as varied as you can.

2 Find a portrait in a book or magazine that you want to copy. Tear up the tracing paper into tonal groups.

3 On a sheet of paper, glue the tonal chips in layers to form the face. Tear them to fit in the shadowed and highlighted areas, so that you match the dark, light and midtones. Think about the way you would build up tonal layers when painting with watercolours.

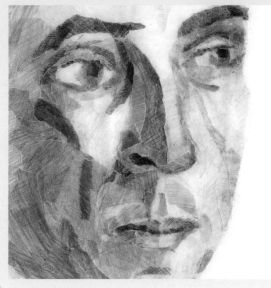

Colour and mood

Do you have a rosy attitude to life or turn green with envy? Colours convey mood through their value, intensity and symbolism.

(89) Colour families

These powerful tools have strong cultural and symbolic associations. Each group has different moods and effects associated with it. These colour families were taken from a watercolour range so the names may vary, depending on the medium and manufacturer.

Reds
Red is hot and strong, and can signal conflicting emotions, from passionate love to rage and even violence. It may take some experimenting to find your favourite tone of red.

Clockwise from top left: perylene maroon, perylene red, vermilion and cadmium red.

Yellows
One of the primary colours in Native American art, bright yellows are energising, hopeful and upbeat. They represent illumination, inspiration and sometimes trouble. Landscape artists often use these hues, but also be aware that yellows can provoke strong reactions in viewers.

Clockwise from top left: azo yellow (aureolin), lemon yellow, new gamboge and cadmium yellow.

Greens
Soothing and calming, greens can also convey jealousy. Although the ones shown here represent an adequate colour range, many artists mix their own instead of trying to find a pre-mixed or convenience green. Do a mixing test with yellows and oranges on one mixing axis and blues and blue-greens on the other. See which greens are produced. Some will be dull, others vibrant.

Clockwise from top left: rich green-gold, phthalo green, cobalt green and viridian green.

Blues
As one of the primary colours and the coolest pigment on the colour wheel, blue is key in mixing both greens and purples. It also represents calm, stability and coldness. Ranging from blue-green to blue-violet, this colour is complementary to red-orange, orange and yellow. It can always be relied on to grab attention when placed as a counterpoint in a painting.

Clockwise from top left: cobalt blue, cerulean blue, peacock blue and ultramarine blue.

(90) Colour studies

Different dominant colour schemes give these otherwise identical compositions extremely different moods (below). The blue painting creates a scene that is much cooler and calmer, whereas the red version is very brash and aggressive.

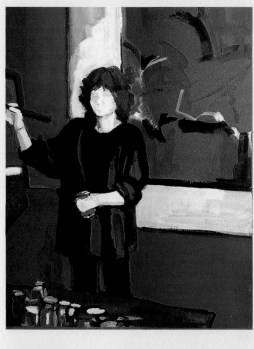

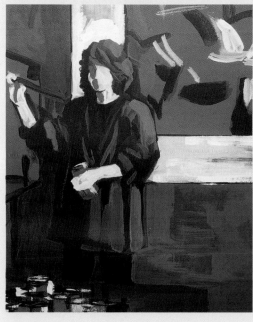

91 Light and bright

Study the faces of happy people. Their faces practically glow with colour. Happy hues are good for conveying cheerful moods (right). Use bright pinks and rose tints to exaggerate the joyful expression of a person filled with life and laughter. Use a value scale to establish accurate modelling effects across the entire face and not just the cheeks.

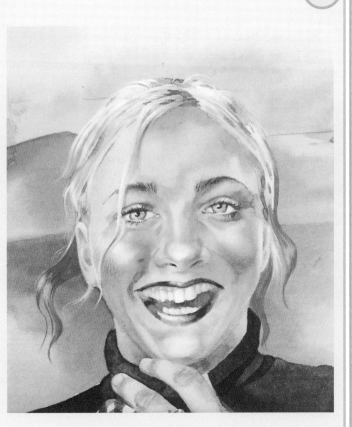

92 A change of heart

In this artwork the mood of the model is more subdued and reflective (above and below). Large planes of light colour highlighted with pink and rose frame the face. The source of illumination on one side hints at the contours. The viewer's imagination completes the rest.

93 Extreme exaggeration

A limited colour palette and narrow values are used to create this silly portrait (right). Make your own colour caricature by exaggerating a personality characteristic of a friend or foe.

Light effects

Colours depend on the amount of actual light and the direction it is coming from. These two factors dramatically change the colour and tone of anything you see.

Light both creates and changes colour. Colour and light have fascinated artists throughout history. Some have used it symbolically to express spiritual subjects. The Impressionists made a study of light effects and developed revolutionary techniques for expressing them. Monet painted the same subjects constantly so he could study the power of ever-changing light. The weather and the time of day determine the amount of light present and its tone. Consider the difference in quality between a bright, clear, early morning light and an evening light tinged orange by a setting sun. Observe how colours, even white, look different in artificial or natural light. Observe a white object indoors, outdoors, in the shade and in sunlight. Although it remains white, its tone changes according to the presence of light.

94

Colour as tone

When using a very limited palette, you have to discipline your eyes and brain to see colour as tone and forget about the "local" (actual) colours in the subject. This drawing uses three conté pencils: white for the lightest areas, black and brown for the darkest tones. The beige tone of the paper is allowed to show through to provide the midtones. Looking at your subject through half-closed eyes will help you to see the tonal changes more clearly.

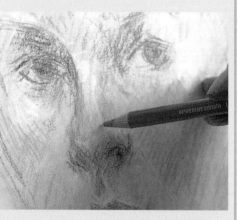

1 Use a black conté pencil lightly to establish the basic shape of the head then position the features. Indicate the shadow areas of the head.

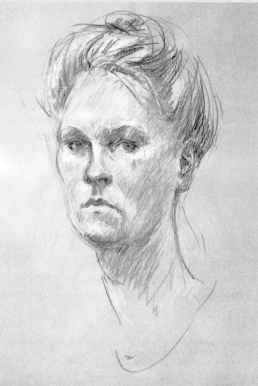

2 Use a white conté pencil to block in the lightest areas on the face and hair. This immediately increases the 3D effect of your drawing. Strengthen the darks with a black conté pencil, then use the brown to introduce a whisper of colour and help "mould" the forms.

3 The finished drawing is elegant and austere with nothing having been too overworked. The combination of dark and light tones, and the use of the paper colour for the midtones creates an effective sense of solidity.

95 **White as highlights**

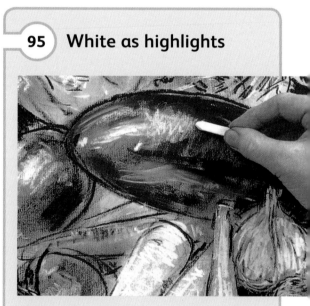

White highlights bring a drawing to life, give it sparkle and help to create the illusion of 3D objects on a flat surface. In this charcoal drawing (above), light is coming over the artist's left shoulder. Dustings of white chalk indicate the lighter tones on the carrots and onions where the light hits. More emphatic white marks describe the brilliant highlights on the smooth, round surface of the aubergine. The contrast between the black of its skin and the white of the highlight creates a dazzling, eye-catching effect. To spot the brightest highlights, look at your subject through half-closed eyes.

96 Seeing light as colour

A snow scene (right) contains a great deal of white in it and the sharp contrasts with the light bouncing off the snow create a dazzling effect. Look at this pastel drawing closely. The artist uses a combination of warm and cool colours to capture both the chill and the brilliant light. Although the snow looks white, there are no pure whites anywhere, not even in areas of brightest sunlight. Touches of warm brown show the texture of the snow. Observe how shadows are made up of cool blues and purples.

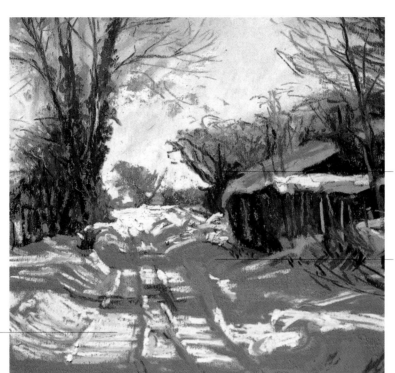

The dark silhouettes of the trees make the sky and snow-covered ground appear even brighter.

Look for colours in the shadowy snow. The artist uses strong blues to set up an intense contrast with the lightness of the snow.

Be creative with your colours. See how their values change according to the pigments that you place alongside them.

97

The ultimate challenge: white on white

You might think that white is just white. Not so! Give your powers of observation a good workout and find the subtle variations on the white theme. Although you see touches of yellow, purple, pink and grey-blue, the objects in this sketch (right) retain their essential "whiteness".

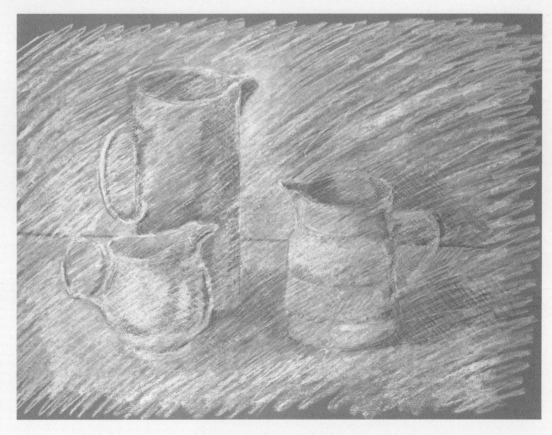

Set up a group of white objects against a white background and notice the different tones and colours created by the play of light. Use toned paper and work openly and loosely, so some of the paper colour shows through to suggest shadows. Notice the subtle colour accents created by light and reflected by the surrounding objects that are not in the picture.

Black, darks and shadows

Much more than just sombre and moody, black is dramatic, sophisticated, subtle and exciting.

Black needs to be treated with respect. Overuse it and your work will become heavy and dead. Used selectively and with a light touch, it can create dramatic and dynamic images and is a great mood enhancer. Use it sparingly to darken other colours and you'll discover some wonderfully subtle shades. As with all hues, the power of darks lies in their interplay with surrounding colours. Black against a dark brown will be less vibrant than black against bright yellow, for example. There are several tones of black (brownish, bluish, purplish and so on). Compare some black objects, paints or fabrics and see the variations for yourself. If you're dealing with shadows, never assume they're just black. Even the deepest, darkest shadows have a subtle colour bias dictated by the quality of light and surrounding objects. Shadows and dark areas play an important part in a composition, adding drama to even the simplest of subjects and helping to lead the eye around a picture.

99 Energy and power

In this painting, highly energetic and dynamic black linework reflects the power of the subject (below). You can almost feel the pent-up energy of the motorcycle and its sense of speed, even though the bike is stationary. Black is not only used to create the framework of the bike and rider but also provides local colour. Loose and open lines allow the white of the paper to show through for highlights and structural information, while watercolour washes complement and enhance this powerful image.

98

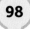

Silhouettes and shadows

Shadows are constantly changing in landscapes so don't ignore them. They give clues about the weather, season and time of day, and set the mood. This wintry watercolour scene (below) is captured using dark areas and contrasting pale washes in a palette without black. The long, soft shadows here indicate late afternoon on a cloudy winter's day. The dramatic tree silhouettes are achieved with subtle dark mixes of earthy colours. Paler tones and less detail create a sense of recession towards the horizon.

1 Lay down soft background washes, then use a dark mix of indigo, alizarin crimson and yellow ochre for the nearest trees. Progressively lighten the mix for trees in the middle and far distance.

2 Add a soft wash over the tree canopy. Suggest the tracery of twigs using a dip-pen loaded with the tree-trunk mix, making it paler for the middle-distance trees. Don't draw every twig. Generalise broadly in the distance.

100 The power of black and white

Black and white is an optically arresting combination with powerful graphic qualities. Linocuts are a perfect way to explore this theme. Make some experimental cuts on a piece of lino with a selection of gouges. Remember that what you cut away won't print. Each tool will make its own characteristic marks, and you can end up with some interesting patterns and textures. Roll black ink onto the lino and print onto white paper. If you're not into linocutting, use white chalk on black paper. Stipple with the tip, make linear marks using a sharp edge, or make broader sweeps with the flat side of the chalk.

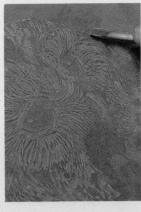

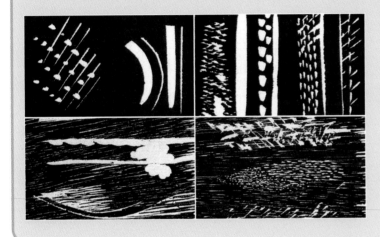

1 An owl with different feather textures is a good subject on which to flex your gouging muscles. It needs a variety of marks and bringing the bird to life means getting the eye area right. Use a fine gouge for the soft feathers that radiate out from the eye.

2 Use different cuts to suggest the feather textures of the owl without showing every single feather. The eye will "fill in" the rest. Add an outline around the bird with a broader gouge to separate it from the surrounding night sky.

101 Negative response

Generally, black lines are used to draw the outlines defining objects, creating a "positive" image. The drawing may then be "coloured in" to give tone and form. The artist here works in reverse, however, and in effect depicts the subject in terms of the negative (right). First, he lays down random layers of acrylic paint in a variety of colours to create an abstract underpainting. When this is dry, he paints the scene using opaque black paint, not only for shadows, but also to fill in the negative shapes and provide areas of "local" colour. This interesting approach produces a dramatic and exciting graphic image, warmed by the underlying washes. There's plenty here to engage and involve the eye.

MODULE

3

Texture and pattern

"There is a [better] chance of an exciting painting from a study with texture." **JOHN FRENCH SLOAN**

All around you are interesting textural surfaces to touch, as well as decorative patterns of repeating shapes to catch your eye. Without texture and pattern, the world would be a flat and uninteresting place. Module 3 begins by exploring how to convey textural effects in art, then shows you how to use pattern to enrich your work.

Actual, implied and invented textures

Give your work real "feel appeal" by using these easy techniques to obtain interesting textured effects.

There are many words to describe textures: smooth, rough, shiny, matte, coarse and feathery to name but a few. The challenge to the artist is how to simulate texture in the real world – perhaps a brick wall, a pebble beach or a mass of foliage – on paper or canvas. A fun way to explore texture is to experiment with different tools and media. Dab, splash and flick paint. Make overlapping marks with a pencil. Use unusual tools, such as a toothbrush, sponge or twig, on rough or smooth paper. Finally, try to re-create actual textures.

⦿ see also
Decorative and painted patterns, pages 68–71

Piecing things together, page 74–75

102
Look around you

Texture adds interest to the objects in our environment. Look out for examples that appeal to you visually such as bird feathers (below). Photograph or sketch those that you like. Incorporate these details into drawings, paintings and sculptures.

Create some interesting designs by experimenting with textured imprints. Press objects into self-hardening clay and remove after a few minutes (right). Record them in a journal.

103 Get touchy feely

Actual texture
Look up close at the real thing: a kitten's soft fur, the scaly skin on a lizard (right), the froth on a glass of soda. Look around you for neat textural surfaces and keep a sketchbook handy to record any interesting effects that catch your eye.

Implied texture
This watercolour of a hawk looks textured but is actually smooth to the touch. Implied texture refers to the illusion created by pens, pencils or paints, which in this case is a fluffy, feathered appearance.

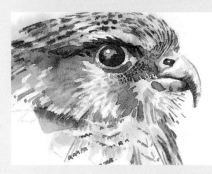

Invented texture
Think of some patterns or textures of your own. They don't have to be realistic. Look for interesting finishes to apply to your artwork. This one is a rubbing made from the sole of a sneaker using coloured pencil.

104 Virtual gallery

Metropolitan Museum of Art Carpet Hunt Click on one of the plants or animals to begin your journey through the texture of the rug. www.metmuseum.org/explore/flowers/flowers/index.htm

105 Line texture

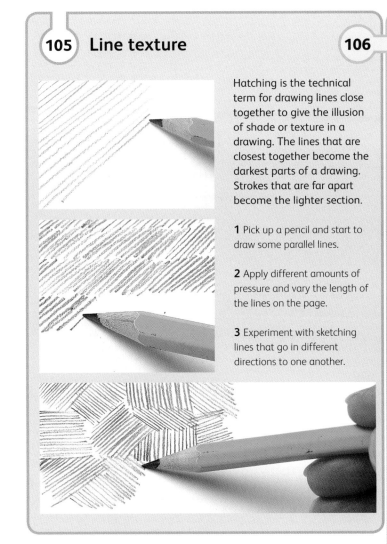

Hatching is the technical term for drawing lines close together to give the illusion of shade or texture in a drawing. The lines that are closest together become the darkest parts of a drawing. Strokes that are far apart become the lighter section.

1 Pick up a pencil and start to draw some parallel lines.

2 Apply different amounts of pressure and vary the length of the lines on the page.

3 Experiment with sketching lines that go in different directions to one another.

106

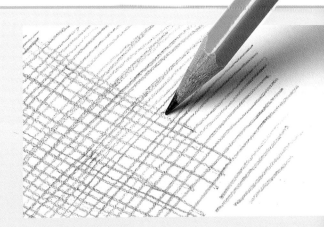

Crosshatching

This technique is a great way to build up tone and render coarse textures. Crosshatching will make any drawing look richer and more realistic. It's very simple to do: start with a series of straight lines, after which you add in other strokes that cross over into them. You can use a graphite or coloured pencils, crayons, ink pens or pastels.

107 Nature's textures

Pinecones are good subjects for practising textured effects. Study the shape of each individual plate, the way it alternates and overlaps with the other scales. Sketch the overall forms, then use the shading techniques below to capture the top and base of each scale, making it darker underneath and towards the heart of the cone.

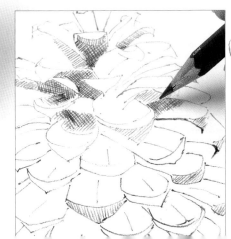

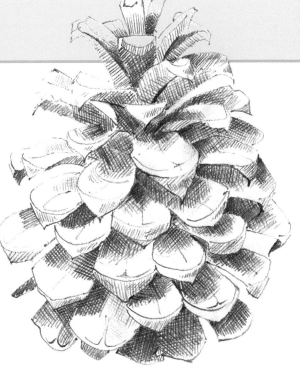

Paper lace **108**

This is a cool technique that requires no special skills and produces really impressive results.

1 Find some lacy fabric; anything with an interesting pattern worked into the weave will do. Lay it on a piece of paper or washable surface, and brush acrylic paint over it.

2 Peel off the lace, sandwich it between two pieces of paper and press down. Peel off the top sheet, remove the lace and you have two sheets of paper lace.

3 How you use your lacy art is up to you. You could use it in a textured collage or as a background for scrapbook pages.

111 Swirling pastels

1 Slice a red cabbage in half. Copy the pattern on the inside.

2 Take a white pastel and a sheet of pink pastel paper. Draw the shapes and fill in the solid white parts.

109 Rubbing it in!

This technique involves placing a sheet of paper over a textured surface and then working a pencil over the top. The technical French term for this is "frottage". Check out the work of the famous Surrealist painter Max Ernst who made this his signature.

"Grate" stuff!
The humble cheese-grater creates a range of interesting effects.

Basket case
Woven baskets, place mats, fabrics and coins have great textures. Experiment with the angle of your pencil, try out different colours and vary the pressure applied.

110 Rough and smooth

Rubbing or "frottage" techniques work best on smooth paper. Textured paper conflicts with the texture to be rubbed and ends up confusing the overall image.

3 Using a pinky-red pastel, draw in the slightly darker areas. These are the midtone values.

4 Use a deeper pastel to draw in the darkest parts or the darker midtone values.

112 Beaded drops

Look at the condensation beads on this ice-cold can (below). Now turn to the painting on the right. How did the artist achieve this effect? The trick to making droplets stand out is by giving them dimension by painting in both the shadows and the highlights. Leave the white paper showing through for the brightest highlights.

113 Collect it: wall art

Create stunning multi-textured wall art (right) with the techniques learned so far. This kind of vibrant piece makes a great conversation starter!

1 Go on a hunt for some interesting textures. Paint, photograph and sketch varied surfaces, recording as many of them as you can find.
2 Use your imagination to invent some textures to add to your collection. The more offbeat, the better.
3 Cut your textures up into same-size squares or rectangles.
4 Display these squares in a grid-like formation. Glue them down on a piece of paper. Repeat pictures to create patterns and produce a strong, unified image.
5 Stand back and admire.

114 Collect it: computer images

Where can you find textures that you cannot see in nature or in the man-made environment around you? The awesome world of computer graphics provides a limitless resource that is yours for the taking. Check out textural images from stock photography sites, desktop patterns or computer magazine sites and download free images. You can also make your own textures using graphics software, duplicating and manipulating shapes to create unique effects.

Computer-generated textures (see above) allow you to develop a new visual language, one that was not available to artists of the past except in their imagination. Keep a reference file of your favourite creations. Remember that none of them should represent natural or man-made textures. Print them out, cut them up into squares and arrange them as a grid in your sketchbook, varying the tones, colours and scale.

115 In the right vein

Nature provides countless opportunities to study and record textural surfaces. Examine a variety of leaves under a magnifying glass or microscope and prepare to be amazed by their fascinating veined structure (below). Use a zoom lens on your camera and photograph large leaves at different times of the year, placing a light source behind them to make them glow. Build up a photographic collage that is either geometric or overlaps in a more random way.

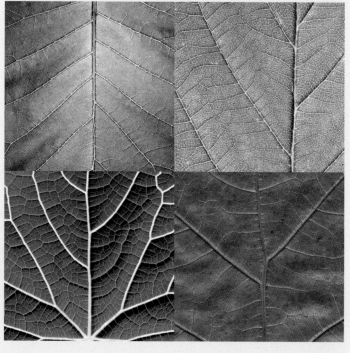

116 Dented and rusty

There are many different ways of simulating real textures in art. How would you render a rusty surface, for example? You could spatter rust-coloured paint over watercolour washes or rub wax crayon over the paper before applying paint. Touches of pastel can also produce rust-like finishes (right). In this painting, the artist built up layers of gouache, then sanded back the surface to reveal the layers underneath.

Computer game designers, too, have access to powerful digital tools and processes that enable them to create realistic props. Whatever the viewpoint, the textural marks are integral to the battered character of this armoured vehicle. Without its rusty texture, carefully applied so it can be seen from all angles, it wouldn't look anywhere near as convincing.

Back Front Side view

Three-quarters view

(117) Collect it: street art

Once considered vandalism and a blight on the urban cityscape, graffiti has now become a valid form of artistic expression. Its graphic letters, patterns and decorative styles (right) have been accepted by the mainstream art world and even adopted by advertising companies and the media. The artist Keith Haring, who died at the peak of his creativity, was one of the first street artists to take the graffiti movement from the streets into the art gallery. His designs use simple shapes to express thoughts about the state of the modern world. Take a virtual tour of the Keith Haring Web site (*www.haring.com*), then compare how other artists have been influenced by his vision.

This grid of graffiti exploits negative space and exaggerated or distorted letters, blends loud colours and uses symbols to visual effect. Develop your own street-style language and put it to practical use. Develop a graffiti-type font into graphic images for clothing or stationery.

(118) Spot on!

For a minute forget pencils and paint. Put your skills to the test by creating a textured pattern made up of small objects, a kind of Op Art mosaic. This striking bull's-eye design (right) is made up of button badges. You can buy plain ones from craft supply companies. Work up the design on a skirt or add it to a piece of strong, plain fabric as a wall hanging.

Mark out a large circle. Tie a pencil to one end of a length of string, secure the other end to the centre of the circle with a drawing pin and swing the pencil around in a circle, keeping the string taut. Pin the badges to the drawn line without any gaps in between. You might need to adjust them to make them fit. Add the next circle of badges and continue to work inwards, changing colour where you like. The texture should be smooth and shiny, but also tactile and raised from the surface.

(119) Virtual gallery

Art Crimes: Writing on the Wall
A collection of graffiti from around the world.
http://www.graffiti.org/

Decorative and painted patterns

Everywhere you look, patterns add spice to reality. Without them, a zebra would be white, wallpaper plain and cutting-edge fashion far less appealing. Be inspired by the endless variety of patterns that are out there to enrich your art.

Different to texture because it contains a repetitive element that texture does not necessarily have, pattern is another fundamental concept in art. It can be purely decorative such as on textiles, wood carvings, mosaics and other handmade items, but also be present in repeating shapes in the natural world. Look out for cloud or leaf patterns or the alignment of windows and chimney pots along a street. The repetition of shapes and colours presents exciting themes.

121 Carve it!

Craftsmen around the world use patterns to decorate their creations, which don't have to be complicated to be effective. The most attractive ones are often based on simple, repeating shapes. Carved boxes such as the one shown below are a good source of inspiration. For ideas, visit an ethnic art museum or take a virtual trip online. Translate your carved design into a linocut that you can use to print borders for your artwork. Alternatively, make different borders and print them one below the other for a bold, graphic design.

120 Collect it: wacky fabrics

If you are interested in decorative art, and especially if you are thinking of studying fashion, this is an exercise for you. Make a collection of fabric and wallpaper swatches in a range of wonderful patterns. Textile designers produce thousands of patterned designs each year, so you'll have no trouble finding them. Now it's your turn to invent your own. Use coloured pencils to create some crazy patterns in your sketchbook. Use fabric pens on squares of cotton fabric to translate these designs into textile swatches. Sew together for a wild patchwork.

Use your swatches to cover one of your sketchbooks. Glue them on with fabric adhesive.

122 Head in the clouds

Nature's patterns are the most impressive of all. Learn how to paint the sky's awe-inspiring patterns right here.

Sky at sundown

Watercolour is the perfect medium for reproducing the effects of a great sunset. Use variegated washes and tilt your paper from side to side to blend them into patterns of graduated colour.

1 Wash over your paper with clean water. Drop in cadmium yellow, scarlet and alizarin crimson.

2 Add some cobalt blue and perhaps a little Payne's grey. Tilt the paper and watch the colours run together.

3 The finished painting dries paler with a subtle colour pattern.

Heavy snowstorm

Falling snowflakes show up clearly against the dark storm clouds in this gouache painting. Don't worry about adding the snowflakes dot by dot. Just spatter the paint on with a brush for an instant pattern.

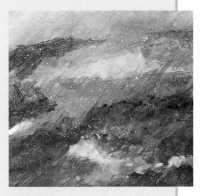

1 Build up a cloudscape as the background, working from dark to light in diagonal brushstrokes.

2 Dilute white paint with water. Load a decorator's brush with paint, pull back the bristles and flick the paint onto the clouds.

3 The pattern of spattered snowflakes adds depth and movement to the painting.

Rain clouds

Use pastel for gentle marks as well as more graphic strokes in this skyscape. When you are describing cloud patterns, don't make them look too solid. Remember clouds are made of vapour, not solid matter.

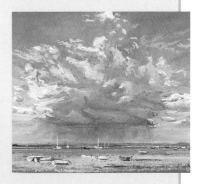

1 Work with pastel on glasspaper. Start with the midtone colours, looking for the patterns in the huge cloud formation.

2 Build up the lighter tones, then add the pattern of white highlights, pressing the pastel down and lifting it with a twist.

3 Finish off the picture with a vertical pattern of rain falling from the distant cloud.

Cloud patterns

Complicated skyscapes are easier to paint if you break them down into areas of pattern. The artist here explores the pattern of clouds using acrylic paints. Try this using the rough side of a piece of cheap hardboard, preparing it first with three thin coats of acrylic primer.

1 Apply the acrylic paint within the pattern areas using a small knife. Create the shape by guiding the tip.

2 Use the knife to blend the colours. Leave any raised edges of paint left by the knife as these catch the light.

3 Highlights applied with thicker paint add cloud-pattern texture.

123 Collect it: star struck

Islamic artists began adorning surfaces with these complex geometric patterns (right) more than 1,000 years ago. Carved into wood and stone, or composed of small tiles, many of these abstract designs were based on star shapes that followed advanced mathematical theorems. Collect examples from books, or visit a museum or mosque. Marvel at how these symmetries were created without help from computers.

You can also buy books which contain Islamic tile patterns presented as line drawings that you can colour in. They offer you the chance to experiment with different tones and colours to make your own unique designs.

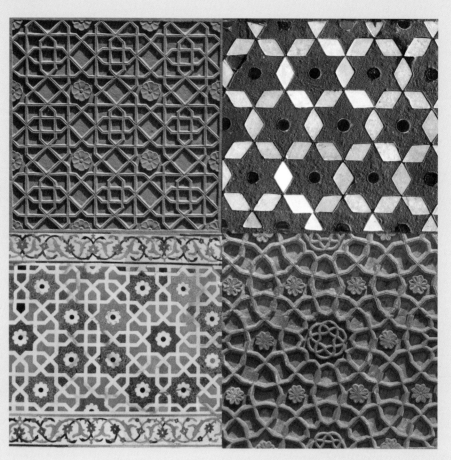

124 Repeating patterns

Repetition is the main feature of pattern (right). In this painting, a collection of curved jars are grouped together on the table to create a pattern of repeating vertical lines and curves. Look at the contrast between them and the strong repeating diagonals of the checked tablecloth, itself echoed by the arrangement of the table legs.

Assemble a group of objects that have similar shapes, such as bottles, tumblers, jugs or cups. Set them up on a patterned or striped tablecloth. Look out for repetitive elements in your objects and paint the patterns made against the cloth.

125 Paper patterns

As illustrated in this painting (right), pattern has most impact if the shapes within the composition are kept uncomplicated. This striking artwork was built up as a collage from pieces of painted paper. The backdrop has a geometric feel, like a Persian rug, and contrasts with the looser, natural pattern made by the flowers in the foreground. Plain areas of red sweep diagonally across the composition to separate the blocks of designs.

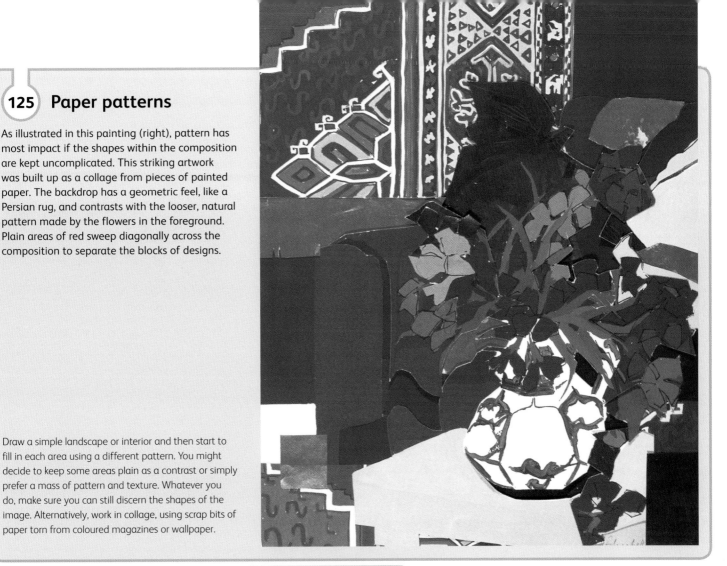

Draw a simple landscape or interior and then start to fill in each area using a different pattern. You might decide to keep some areas plain as a contrast or simply prefer a mass of pattern and texture. Whatever you do, make sure you can still discern the shapes of the image. Alternatively, work in collage, using scrap bits of paper torn from coloured magazines or wallpaper.

Miniature painting

126

This type of painting tradition has a long history in India and Persia. Rendered in bright, natural pigments with pure gold and silver embellishments, these small-scale paintings depict fables, myths and love stories. The scenes are impeccably detailed and accurate. Ornate patterns frame the central image.

Use gouache paint and a fine brush to paint your own highly decorative miniature painting (right). Make sure the composition contains a storytelling aspect. Your work should measure no more than 10 x 15 cm (4 x 6 in) and include gorgeous, richly patterned borders and decorative elements. Use jewel-like colours and a touch of gold paint for a truly bejewelled look.

127 Virtual gallery

A Brief Introduction to Mughal Miniatures An art form brought to India from Iran by the Persians. http://www.chandnichowk.com/ miniatures/min_history.htm

Cool camouflage

128

Although a great streetwear look, camouflage has a more practical function hiding and protecting animals and people in potentially hostile environments.

Nature is the ultimate artist, using texture, pattern, colour and tone to create optical effects that allow a creature to blend into its surroundings. Zebras, lizards, spiders, turtles, fawns and various types of fish are just a few examples of animals that use this ancient technique to survive in the wild, whether as prey or predators. Camouflage in warfare serves the same function. Artists working during the First World War came up with a similarly brilliant idea and military camouflage was born. Inspired by the fragmented appearance of Cubist paintings, they experimented with broken patterns to disguise uniforms, ships and field guns. Since then, it has been absorbed into popular culture through fashion, skateboarding and videogame art. Camouflage is fun and will test your observation skills to the limit.

Camouflage patterns

Our environment is full of pattern and texture. Camouflage breaks up solid colour into irregular fragments, so the eye is "tricked" into reading objects as part of the background.

Desert camouflage

Jungle camouflage

Forest camouflage

The three military camouflage patterns (left) are designed to suit different environments. Look out for similar effects in everyday life. Find the umbrella hidden against the fallen leaves.

129 ## Now you see me, now you don't

Some animals are masters of disguise. They use graduated tones and colours, or bold patterns on their fur, feathers or scales to disappear into their habitat.

These buff-coloured lizards are almost invisible in their sandy, rocky environment. The subtle tones on their skin create an effect of light and shadow.

A Pointillist painter couldn't have done a better job at disguising this flat fish with its tiny dots the colour and texture of the sea bed.

130 Natural habitat

Camouflage presents an interesting challenge to the artist. It's not just the illustration of the subject, but also its surroundings that become important features in themselves. Compare the patterning on an animal like the tiger with the colours and shapes of its habitat. Analyse why these markings work so well in enabling it to blend into this background. Try to reproduce this effect in a painting like the one above, where the tiger's stripes appear to be a continuation of the tall grasses.

131

Urban giraffe

Play around with camouflage by using it to hide animals, people or objects in a composition. Force your viewer to look more closely. This giraffe (right) is in an unlikely urban setting against a high brick wall. Its patchy markings, so effective at camouflaging it against the trees, bushes and grasses of the African savannah, suggested a pattern of bricks to the artist. As you can see, a giraffe might be equally safe from predators on any urban street!

It is not just its green colouring that helps this butterfly disguise itself on a plant. The pointed wingtips echo the leaf shapes, while the broad, pale bands across the wingspan mimic light reflecting from the shiny leaf surfaces all around.

132 Virtual gallery

Bev Doolittle This wonderful artist paints wildlife camouflaged in its habitat.
http://www.webagora.com.br/1/bdoolittle1.htm

How Military Camouflage Works In war, the function of camouflage is very simple: it hides the soldier and his equipment from enemy eyes.
http://science.howstuffworks.com/military-camouflage.htm

Piecing things together

Texture and pattern are important elements in the art of mosaic, which has survived for thousands of years to become an expressive modern art form.

Mosaic – the art of creating complex designs from small pieces of coloured glass or stone – combines a tactile textural surface with a beautiful decorative pattern, and is now a popular artistic medium in its own right. In the past, Egyptian temples, Roman villas, early Christian churches and important public buildings contained mosaics that were both intricate and durable. No longer just for decorating buildings, mosaics embellish small items, too, such as tables and boxes to create exciting, one-of-a-kind pieces. Mosaics are the ultimate recycler's dream. Instead of pre-cut tiles, you can use all kinds of "recovered" objects (fragments of old pottery, broken tiles, pieces of wood, coloured plastic, broken glass, shells, beads and buttons). The more varied your materials, the more textured your mosaic.

134 Smash it!

Zany mosaic designs (see above) incorporate different materials of all shapes and sizes. If you want to try your hand at this spontaneous art form, rummage around for old, unwanted plates and tiles that you could recycle in a creative way. Decide on the colour scheme. You might want to use a limited range, varied tones of one colour or go completely crazy. Here's the best bit. Pick up a hammer and smash up the pieces before arranging and gluing them down on the baseboard.

133 Basic mosaics

Ancient mosaics were made up of pieces called *tesserae* that were roughly the same size. If they were good enough for the Romans, they're good enough for us! Many mosaic artists today still create subtle and detailed works using similar-sized pieces. This simple design using pre-cut tiles (below) makes a good starter project for getting to grips with this technique.

1 For areas of larger, pre-cut tiles, apply glue to the baseboard with a spatula. Place the tiles on the wet glue. Only lay down an area of glue that you can cover with tiles before the glue dries.

2 For detailed areas with small pieces, reverse the process and apply glue to the back of each piece with a fine brush before positioning it on the design. Do not apply too much glue or the work will start to get messy.

3 Tiny pieces are hard to handle with your fingers. Use small tweezers, a wooden toothpick or a fine metal skewer to manoeuvre them into place.

135　Mosaic meets montage

Paper lends itself perfectly to the mosaic technique and you don't have to go for expensive art papers. Check magazines for interesting clippings, use old photographs, computer printouts or simply scraps of handmade paper. Keep old wrapping papers or use tissue paper (scrunch it up, smooth it out then cut it to size for an interesting texture). Combining different types of papers adds surface texture and tonal interest to any design. This bright picture of a little girl wearing a yellow raincoat uses a mixture of techniques borrowed from both mosaic and montage work. Create a simple line drawing of your own and try interpreting it in this way.

1 Draw your design on tracing paper, then flip it over and scribble over the drawing. Trace over the lines with a soft pencil, and prepare to transfer the shapes onto the coloured papers.

2 The raincoat needs several shades of yellow and orange to create the shadows that give it form. Lay your drawing right-side-up on the main yellow paper. Draw over the outline shapes.

3 Cut out the shapes carefully with a sharp craft knife.

4 Assemble the raincoat, piece by piece, gluing it to create a montage with overlaid shadow pieces. If you're confident enough, you can guess where these go, otherwise transfer them and cut out as before.

5 The subtly montaged figure makes an eye-catching contrast, both in terms of colour and technique, to the tessellated mosaic-style background with its geometric shapes. The yellow raincoat stands out brightly from the complementary blue of the background, while the green umbrella links the two together. Notice the use of white paper that "reads" as lines that are part of the design.

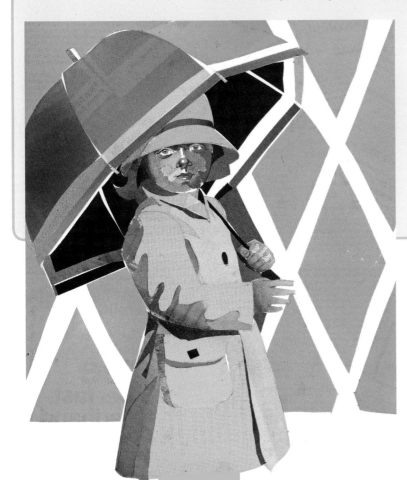

136　Virtual gallery

Mosaic Maker Create a photo mosaic from digital photographs.
http://bighugelabs.com/flickr/mosaic.php
Sonia King One of the best mosaic artists working today.
http://www.mosaicworks.com/gallery/index.html

Glassy and glossy

Surfaces with smooth, shiny textures are interesting to draw and paint as they create reflections. Glass, metal and china have reflective qualities, as do landscape features such as lakes and rivers.

As an artist, you need to know how to depict the highlights and reflections set up by objects with a glossy texture. Reflections can be the main theme of your composition if you choose a subject such as gleaming modern skyscrapers, highly polished cars or a pool full of swimmers. Use your observational skills to depict the glint of light on a shiny edge or a reflection distorted by a curved surface.

138 Mirror reflections

A mirror is the most common reflective surface in daily life. Because an ordinary mirror is flat, it reflects its surroundings accurately, making objects appear normal and natural without any distortions.

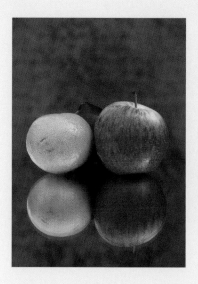

Set up a still life using a few simple items (like an apple, an orange and a red pepper). Place the objects on a mirrored surface. Notice how the composition takes on a pleasing symmetry. Compare this with the distorted and curved reflections on the sunglasses shown opposite.

137 Polished perfection

When rendering any kind of reflection, remember to paint what you can see rather than what you think is there, even if this is a strange abstract shape. It takes a while to work out what is going on in this shiny and cheerful composition (right). Once you realise that the colours and shapes at the top are reflections from the set of crayons in the highly polished plastic dish at the bottom of the picture, all becomes clear. Set up a still life of your own with some reflective objects and use a viewfinder to focus on one abstract part of it. Alternatively, find a suitable photograph in a magazine and mask off a section of it. Draw or paint the shapes and tones that you see framed.

 see also

Distorting form, page 82

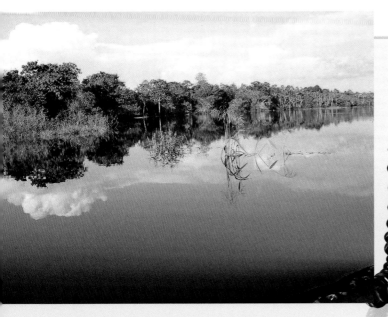

Place a glossy object on a shiny surface. The white streaks on the telephone below reflect light and are reproduced in the reflection. Pick up on this kind of detail when sketching.

As this photograph of the Amazon river shows, still water is like a huge, flat mirror. If you are painting water reflections, make them more subdued in colour and tone than the objects reflected on their surface.

139 Distorted reflections

Designer sunglasses preserve the wearer's allure as they reflect back the world. Ask a friend to model an oversized pair for you. Paint what you see reflected in the lenses.

1 Observe how lenses distort the scene being reflected, so that the perspective of the building opposite is altered and the window curved. The artist uses a wide range of tones for the reflections and keeps the edges of the building crisp.

2 The girl's eyes, superimposed over the reflections on the lenses, create a surreal effect.

3 The finished painting focuses on the sunglasses, but the reflections give the viewer several clues about the girl's location. Can you guess where she is?

140

Metallic glints

Metal surfaces offer endless scope for painting highlights and reflections. In this surreal painting done in acrylics (below), the sheen on the tin is shown up by textural and tonal patterns. The pale bands show glinting light. Collect some containers and try it.

MODULE

4

Form and space

"The essence of drawing is the line exploring space." **ANDY GOLDSWORTHY**

Able to create the sense of 3D space and distance on a flat 2D surface, and turn simple outlines into convincing solid objects or "forms", artists are true masters of optical illusion. Module 4 gives you the know-how for creating these "impressions", as well as introducing you to techniques for manipulating objects and their surrounding space in order to create compelling compositions.

Overlapping images

When we look at a painting in which several objects or figures are placed one in front of the other, we interpret it as having a sense of depth. Overlapping images are an important element in creating a 3D world on flat paper.

A simple art technique, overlapping creates a feeling of space on a flat surface. Before the rules of linear perspective were developed in the fifteenth century as a way of portraying distance convincingly, artists relied on overlapping images for depth.

141 A change of scene

A photograph of a beautiful landscape is always inspiring, but think how much more fun you could have with it if you cut it up and rearranged it so it wasn't quite what it seemed. Do this with a couple of photos and a pair of scissors, or use your computer software to help.

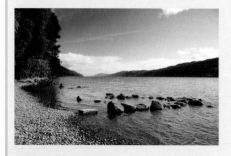

1 Choose a photo (or photos) of a simple landscape with a clear horizon line, a good sense of distance and foreground interest.

2 Cut the photos into strips using scissors or duplicate the image on your computer screen. Select rectangular sections. Re-assemble the strips to create a subtle shift in the composition of the landscape.

3 Take your overlapping image a step further and paint it, filling in the overlapping sections with textural marks. If this technique interests you, research what other artists have done with photomontage.

142 Cubist breakfast

While overlapping usually suggests depth, the shapes in this mixed-media, Cubist-style still life look flat. This is because there is no realistic perspective, only an interesting pattern of shapes.

1 Make a charcoal sketch of the objects, using a coffeepot or jug with flat facets if possible. In true Cubist style, show the pot and napkin from a variety of angles rather than in "real" perspective.

2 Add acrylic medium and embed scrim, burlap and newspaper into it for a textured background.

3 Use oil paints for the flat surfaces of the coffeepot. Paint over the newspaper, so that the pot overlaps it.

4 To add colour and a bit of variety to the various overlapping shapes, paint in features such as the napkin and croissant.

143 Two, three, four or five's a crowd

If you like drawing people, you'll want to tackle a
large group or crowd scene with overlapping figures
sooner or later. A fun way to practise this is to set up
several artist's mannequins to mock up a small crowd.
Avoid a confusion of limbs and bodies by drawing the
background figures lighter in tone (right). Make the ones
in the foreground sharper and more detailed. Another
way of playing around with overlapping mannequins is
to use graphic software programmes that duplicate
the same photographic image onto different
layers. Use a different colour and opacity
for each layer, then apply different
layer blending modes. As overlapped
figures move into the background, they
become progressively paler and less distinct,
creating a 3D feel.

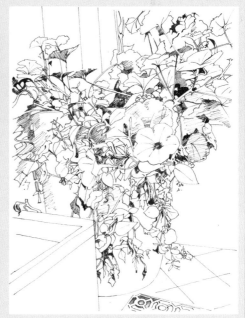

👁 see also

Getting things into
perspective, page 84

Oil-based media,
page 108

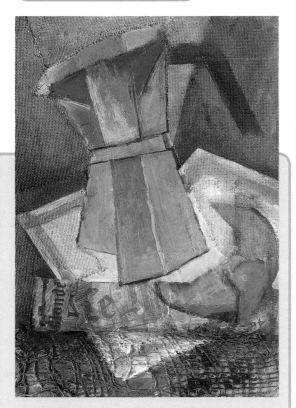

5 In addition to the overlapped images, the artist has
superimposed layers of fabric and paper for a rich,
textural finish.

144 Say it with flowers

A display of flowers is a mass of overlapping shapes. Don't try to draw every
single one, but concentrate on the overall pattern of shape and tone instead.

1 A drawing pen will give you a fine
line of a constant thickness. Draw the
main flower shapes, then look for the
shadow areas and fill them in with
dark tones.

2 Use hatching to create midtones
on some of the leaves and flowers.
This will help to isolate them from the
mass of lines.

3 The artist uses dark and midtones to separate
the flowers so the viewer is not distracted by too
many overlapping images.

Distorting form

One of the most exciting aspects of art is changing the world around you. In charge of the creative process, you can bend, twist and interlock shapes at will.

Throughout the ages, artists have used distortion to express extreme emotions. Study Edvard Munch's *The Scream* (1893) or the nightmarish figures of Francis Bacon. Without the distortion of the human figure, these artists couldn't have expressed panic and despair so well. Distorted images can also be fun, of course, throwing up new angles on familiar scenes or objects. Tessellation, too, provides wide scope for surprising the viewer.

145 Kitchen sink drama

Objects seen through water (right) appear distorted because of refraction or the bending of light. When water is seen swirling around as in this kitchen sink, the effect is magnified. The broken water distorts the outline of the cutlery and items appear to dissolve into the liquid.

Submerge a few objects in a bowl of water to try and capture a similar distorted effect. Take a digital photograph to "freeze" the movement. Use this image as a reference for a painting.

146 Who's in the picture?

Tessellations are shapes that fit together to form one continuous repeating pattern. The twentieth century Dutch artist M. C. Escher was a master of tessellations and created fascinating interlocking designs of birds, animals and other images. Some geometric shapes fit together perfectly. If you alter them slightly, you can make familiar forms that interlock. The pattern on the right is based on equilateral triangles curved to make up the face of a famous artist. Can you guess who?

(147) Conveying a mood

Examining the work of other artists is vital for exploring different styles and subjects. In this oil painting of an old-fashioned typewriter (right), the colours are naturalistic and the handling of the paint is descriptive. However, the picture has taken on a dreamlike character through the subtle distortions of the subject. What was the painter aiming to convey? Perhaps that frustrating feeling of writer's block when confronted with a blank sheet of paper. Visit a local art gallery and locate an artwork that communicates a mood using distorted shapes. Take notes, write a description of the painting and explore the technical aspects. Finally, ask yourself what the painting means to you. Using the notes that you have gathered, create your own distorted shape painting. After you have completed it, analyse it! It will help you to develop a way of talking about your own art.

(148) Convex mirror

Distorted images do not have to come from your imagination. You can set up your own by using a convex mirror, as the artist has done for this oil painting of his studio (right). He places the mirror on the floor, then stands beside it with his easel. The curvature of the mirror changes all proportions and his figure becomes impossibly elongated with huge feet and a tiny head. The walls of the studio are captured within the circle of the mirror, rather like a photograph taken through a fisheye lens.

(149) Virtual gallery

Tessellations Explore designs that fill a page and form a pattern.
http://www.tessellations.org/

Edvard Munch View *The Scream* at
http://www.ibiblio.org/wm/paint/auth/munch/

Francis Bacon Examine his twisted and contorted figures in detail.
http://www.francis-bacon.cx/triptychs/three_studies.htm

Getting things into perspective

The term "perspective" refers to a simple set of techniques that help artists create depth and distance on a flat surface. Linear perspective and aerial perspective are the two most important examples.

As they recede into the distance, you'll observe how objects of the same size appear smaller and parallel lines look as if they are converging. The simple technique of linear perspective reproduces this effect on flat surfaces such as paper, allowing even sidewalk artists to represent art and architecture in a dramatic way. First of all, familiarise yourself with the basics associated with these optical tricks: the horizon line goes horizontally across your picture at eye level; your viewpoint (eye level) will be different if you sit or stand; the vanishing point is the spot on the horizon line where parallel lines converge. The diagrams below explain everything.

150 Aerial perspective

Objects appear clear and detailed up close, but become blurred and indistinct as they get further away. Colours, too, are stronger at close proximity. Far away, they soften and become bluer. No, you haven't got bad eyesight! What you're seeing is the atmospheric effect that causes light to change and colours to alter with distance. This effect is called aerial perspective and you can imitate it in your drawings to create a powerful sense of recession.

The bark of the trees that are closest can be seen clearly, but details gradually get lost with those appearing further away. The far distance recedes into increasingly paler and softer tones.

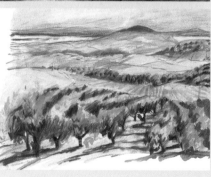

The artist uses colour to express distance here. Study how vibrant blues, greens and strong shadows advance into the foreground. Further in the distance, however, they start to soften.

152 Linear perspective

Depending on your viewpoint, objects have one, two or three vanishing points. When you start a drawing, plot the perspective lines lightly or simply bear them in mind as you work.

1 Look at a box face-on. With one-point perspective, the horizontal lines at the front remain parallel, but the lines of the top converge at the vanishing point on the horizon line.

2 If you look at the box from a corner angle, you'll see two sides. With two-point perspective, the parallel lines of each face and the top of the box converge at two vanishing points on each side.

3 Look at a tall box from above. With three-point perspective, the parallel lines of the sides will appear to get closer together towards the base. This means you'll have a third vanishing point (great for dramatic skyscrapers).

151 Virtual gallery

University of Chicago Learn about the history of linear perspective.
http://www.artic.edu/aic/education/sciarttech/2d1.html
Museum of Science Boston
Marvel at Leonardo's da Vinci's sense of perspective.
http://www.mos.org/sln/LeonardosPespective.html

153 Choosing a viewpoint

When you're planning a composition, your viewpoint (or eye line) has a powerful effect on the dynamics of the scene as it changes both the angles of perspective lines and the impact of the various elements. A high or low viewpoint creates a greater dramatic effect than a central viewpoint. Test all three and observe the effects.

1 A central viewpoint creates a rather flat, unexciting composition, effectively dividing the picture plane into two halves, so any converging perspective lines become less dynamic. The eye is taken straight to the centre of the scene, bypassing other elements, and gets stuck there.

2 A low viewpoint creates drama. The chair takes on a sense of grandeur because the viewer is looking up at it. The height of the hallway is emphasised as perspective lines become more forceful and dynamic, drawing the eye to the focal point. The stripes on the rug appear closer, "elevating" the chair.

3 A high viewpoint creates a gentler, more intimate setting. The rug on the floor leads the eye more slowly along the hallway towards the chair. The ceiling is all but lost, reducing the sense of height and grandeur. It's an altogether friendlier and less intimidating proposal than the scene created by a low horizon line.

154 Objects in perspective

Every object you choose to draw, whether buildings, streets or interiors, can be viewed and portrayed in perspective, even the human figure. The same rule always applies: things get smaller and parallel lines converge as they recede from you. Take the car below. Basically a modified cube, it responds to one-point perspective like the box on the opposite page. The viewpoint will change its impact.

Try drawing a car from different rotational angles and height viewpoints.

155 Pavement art

Street artists create jaw-droppingly realistic chalk masterpieces on city pavements around the world. Look up Julian Beever's work. He creates astonishing 3D effects with chalk on a flat surface (right and below). The clever use of perspective really does look like the earth has opened up. Find a chalk-painting event near you, where free drawing spaces are provided for young, new talent. Alternatively, paint a wall with blackboard paint and draw over it with chalk. When you're tired of your drawing, you can wash it off and start again. Take photographs of the finished piece.

156 Virtual gallery

Julian Beever
Amazing chalk art by a great pavement painter.
http://users.skynet.be/ J.Beever/pave.htm

Negative space

For every positive shape, there is a negative space surrounding it. This is as important to the overall success of your composition as the main subject.

When you are drawing, it is tempting to just look at the objects themselves without thinking about the space around them. Organising your composition involves looking at the whole picture. Take time to become more aware of the negative shapes so you can capture the relationship between the objects with greater accuracy. See the negative areas as additional shapes, not as wasted white space on your drawing paper.

157 Pretty flamingo

The elegant, elongated lines of the legs on a pink flamingo create beautiful negative shapes against the buff-coloured background (right). Your eye is particularly drawn to the triangle formed by the raised leg of the central bird. Look, too, at the curved negative shape created by the flamingo's graceful neck and body. The painting becomes a jigsaw puzzle of interlocking shapes.

The unworked paper background is brought into the composition as a negative shape in its own right. As a dark tone, it helps bring the flamingo out into the foreground.

158 From positive to negative

A digital camera is a useful resource for gathering inspirational ideas. Take some digital photographs of interesting objects or buildings with distinctive outlines. Upload the images into a digital viewing programme. First of all, make a straightforward line drawing of one of your photographs, concentrating on the main features. Now make a second drawing. This time focus only on negative space, ignoring the subject. This takes getting used to as your eye is naturally drawn to it. Shade in the negative shapes you have drawn. See how the result compares with your positive drawing. If your observation has been accurate, the proportions will be the same.

Choose your photograph
A building with strong architectural features such as the ancient Chinese pagoda makes a good subject. Photograph it from a low viewpoint against an uncluttered backdrop such as the sky.

159

Visual tricks

Glance at the image below. What do you see at first glance? Probably two green heads facing one another in profile. Look for longer. Does a red urn suddenly appear between them? Once you have seen this, you can switch between the two images at will. This is a perfect example of negative and positive space interacting. Use coloured paper to cut out some optical illusions of your own. Place the reversed images on either side of a sheet of paper. See if you can turn the negative space between them into another recognisable object.

160 ## The shapes in between

This exercise will help you become familiar with looking for the negative spaces between objects in a still life. Choose a few simple items and arrange them in a group.

1 Instead of drawing the items themselves, search for the spaces and abstract shapes between them. Draw or paint these shapes with thick lines and the objects in your still life will gradually start to emerge.

2 Paint the negative shapes in a solid colour. Your result is a semi-abstract drawing with strong outlines.

3 You can recognise the objects in the finished painting but they form a flat pattern instead of looking 3D.

Make a positive drawing
Work up a simple line drawing of the structure, concentrating on the proportions. Include features such as the columns, through which the background is visible, but leave out any decorative details.

Focus on the negative space
Now make the mental leap. Ignore the building and draw in the abstract shapes formed by the backdrop instead. Shade in the negative space and the building will appear as a white silhouette.

Where will you lead your viewer?

When it comes to your artwork, you are directing the show and have the power to guide your viewer through your composition.

When you create a picture, you have complete power to manipulate the gaze of your viewer. Employ a variety of visual devices, so he or she enters at the point that you want him or her to, travelling into and around the composition on a clearly designated path. If done properly, the viewer's attention stays with the painting or drawing, taking in everything you want to say about the subject.

161 The viewer as participant

As do echoes of colour, the location of objects in a painting act as signposts that lead in the eye. In *Hélène Rouart in her Father's Study* (1886) by Edgar Degas, the empty chair is an invitation for the viewer to enter the scene. Warm brown tones encircle the girl in her complementary blue dress. The same blue of the horizontal line above her head stops the eye from wandering off at the top of the picture. Her hands direct us to the desk and from there to the reflection in the mirror. She looks out at the Egyptian artefacts reflected there, so we, too, look at them and see what she sees. The eye then wanders back to her face and repeats the cleverly directed circular journey.

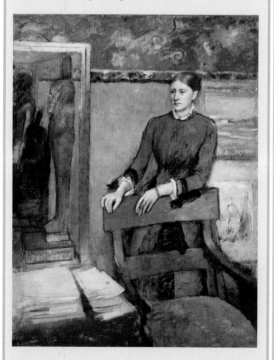

162

Here's looking at you, kid

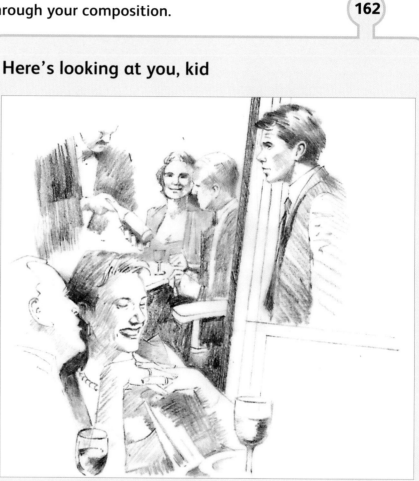

Another device used by artists to direct their viewers through a scene is the eyes of the subjects in the composition. Study this drawing in coloured pencil of a group of people chatting in a café (above and right). A couple is talking in the foreground. The man is attentive to the woman and she is lost in conversation. Although her eyes are closed, she is the viewer's first point of contact. Behind them are three people seated together at a table. The woman in the background draws the viewer into the composition by directly looking out. The man seated to her right is gazing at the indistinct figure of the waiter across from him. To the right of the picture plane, we see a young man coming in through the door. Who is he making eye contact with? His gaze pulls the viewer across the room. Prepare a drawing that tells a story through the eyes of your subjects. Use a similar technique to move the viewer around your composition.

👁 **see also**

A balancing act, page 32

163 There's always something to draw

Even on a long-haul flight or bus journey, there's plenty to fill up a sketchbook. This sketch (right) makes good use of such a confined space, and the artist chooses to draw from the restricted view of his seat. The resulting drawing is a good exercise in manipulating the eye by using quality of line and tone. Your eye is first drawn to the darkest areas of the composition, such as the artist's knees and feet, and the floor area of the cabin. This creates an interesting pattern of negative spaces. From there, the eye gazes up as it travels up the back and over the top of the passenger seats. Only for a very short distance, however, as steep perspective lines and the tone of the luggage rack restrain the eye at the centre of the piece, forcing it to return its gaze, which finally comes to rest on the feet.

164 Get framed!

As the artistic director of your compositions, why not make the frame part of the creative process? Focus in on a small part of your subject and enlarge it to fill a frame. Make sure it tells the story you want. Be creative with your framing, include it in your painting and use it to help concentrate your viewer's gaze where you need it most. Divide the image into segments, as in the panoramic skyline below, so each portion stands alone as a composition in its own right, and yet works as a whole to create a dramatic cityscape.

165 Virtual gallery

Timken Art Museum Move around and the eyes in Peter Paul Rubens's *Portrait of a Young Man in Armour* (1620) follow you. Test it.
http://www.timkenmuseum.org/1-dutch-rubens.html
International Sculpture Centre Discover how sculptors guide viewers through their art.
http://www.sculpture.org/documents/scmag05/sept_05/opie/opie.shtml

Casting shadows

Whether the sun or a bright lightbulb, objects lit by a strong light source cast shadows on the surfaces around them.

Shadows give a real sense of depth to your artwork. Objects will feel more solid and permanent rather than just appearing as if they are floating in space. Without shadows, scenes and still lifes look flat and uninspiring. A shadow anchors an object to a surface or to the backdrop behind it.

166 Light direction

Shadows change shape, depending on the position of the light source (below). To make the shadows cast by the glass long, the light source is low and on the left. For the white eggs, it is low and on the right. As you can see from the push pins and brown egg shown below, overhead light creates a small area of shadow. If lit in a certain way, some items, such as the fork, throw dramatic, even spooky shadows.

167 It's all an illusion

Shadows create a feeling of depth, and are a vital part of a technique known as *trompe l'oeil*. This French word means "deception of the eye". In this painting (right), the artist convinces the viewer that a flat surface is actually a real, three-dimensional pinboard. The lights and darks are very important in giving the objects a three-dimensional feel. In the finished picture, the illusion of the pinboard is complete and would certainly make you do a double-take if you walked past it. The cast shadows make the items look as if they are overlapping and sitting slightly proud of the surface. Notice the subtle colour of the shadows (rarely are they just grey or solid black). Doesn't the finished painting just tempt you to reach out and take an object off the pinboard? Try some artistic deception of your own.

All scraps of paper, ribbon and trinkets look real because they have been painted with the light source in mind.

168 Cartoon shadows

Cartoon actions and poses tend to be exaggerated and a sense of movement is key. Shadows help anchor a figure to the ground or it could look like it is capable of flying off the page! The complex shadow of the baseball player (right) echoes the movement made by his body and bat, while the figure leaning on the cane has a suitably static shadow.

(169) Mood lighting

Be your own lighting technician and set up a still-life group using light effects to create a specific kind of atmosphere. In this moody piece (right), diagonal beams of light from the left create strong cast shadows across the objects on the table. The artist first plots the position of the objects and then outlines them accurately. There is no indication of where the shadows will go at this early stage. He crosshatches with B and 2B pencils to build up layers of shadow, leaving the extreme highlights on the cloth and plate as white paper. To complete the drawing, he uses a soft 4B pencil to create some very dark tones for the deepest shadows.

1 Keep your initial drawing light as a guide to the main shapes in the arrangement.

2 The artist gets to grips here with plunging certain key areas into shadow.

3 Compare the shadow patterns established in this tonal sketch with the finished drawing.

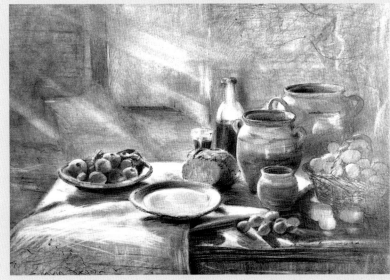

4 In the completed still life, the artist adds beams of light on the left by removing the graphite with a plastic eraser.

(170) Virtual gallery

William Michael Harnett
Late 19th-century Irish-American painter with a *trompe l'oeil* style.
http://www.artcyclopedia.com/artists/harnett_william_michael.html

3D space

Now that you've discovered how to make an image look "real" on flat paper, try creating some real 3D models and figures.

Whether you are working with natural clay, plastic, styrofoam or other modelling materials, it is satisfying to create a solid piece of art that you can touch and view from all angles. 3D work is your chance to use your hands to shape materials into lifelike forms or abstract flights of fancy. Why stop at conventional materials? Famous sculptors have used car and bicycle parts, tools, natural materials and stained glass in their sculptures. If you don't mind an ephemeral work of art, use snow, ice or sand.

(171) Build a biplane

Have you ever made a model airplane? Why not create your own design and model it from polypropylene (left)? This synthetic plastic is transparent, so you can trace sections of your design straight onto it. Score along the lines with a creasing tool and cut out the sections using a craft knife. Either slot the sections together or glue them with a hot-glue gun.

Knead it!

Mould your clay so it has an even consistency without air bubbles. Work on a hard, smooth surface covered with a piece of canvas.

1 Wedging clay is just like kneading bread. Place your hands on either side of the lump of clay. Push it hard downwards and away from you.

2 Roll the clay back towards you, then push it downwards and forwards, as in step 1. Try not to fold the clay because this traps air bubbles. Enclose the clay with your palms to stop it from spreading sideways.

3 The lump of clay should look like a ram's head. Keep pulling the clay towards you, then push it forwards at least 30 times. You should hear the crackle of air bubbles bursting.

Clay slip (below), a mixture of clay and water, is used for joining pieces of soft clay.

(172) Sculpt a solid figure

Air-drying clay is a good material for sculpting small models, and you don't need to fire it in a kiln as with natural clay. A small seated figure (right) is easy to make. The trick is to build up the form section by section from basic shapes that you smooth together and shape with a modelling tool. When your figure is complete, simply leave it to dry, following the manufacturer's instructions.

(173)

1 Shape a cube from clay. Roll out a base. Score the bottom of the cube and part of the base, moistening both with water, and press the cube into the base.

2 Roll out two clay sausages between your palms for the legs. Bend them at right angles at the knees and ankles. Score and wet them so they join the cube and base.

3 Using a modelling tool, shape the rounded forms of the legs. Add small pieces of clay to model the thighs and buttocks. Smooth over.

174 Tactile landscape

This sculpting exercise, where the form stands out slightly from the background, is based on a method called "bas relief", which is French for "low relief". You'll need some Styrofoam cut into squares, a marker, double-sided tape and a craft knife to sculpt this hilly landscape.

1 Glue a series of cut Styrofoam tiles in a row. Draw a simple landscape design on them with a marker.

2 Using a craft knife, cut out the individual hill shapes. Start with the smallest slopes (those furthest away from the viewer), then turn to the larger and nearer mounds.

3 Fix the first layer of shapes to a backing board using double-sided sticky tape. Glue the remaining shapes on top, layer by layer.

4 Once you have stuck on the final layer (the hill closest to the viewer), use an old kitchen knife to trim along the edges.

5 Use a small wire brush to shape and smooth the relief so that the finished landscape has a sense of perspective.

4 Add rolled clay arms and an oval for the head. Cover the head with thin slabs of clay for hair.

5 Finalise the shape with the modelling tool. Leave to dry. Cut away any lumps using a knife.

175 "Live" wire

For complex sculptures, make an aluminium wire framework or armature to give your figure structure and stability. You can leave it inside the sculpture as a skeleton, but if you plan to fire the statue, you must remove this armature first.

1 Bend the aluminium wire into a basic anatomical shape rather like a skeleton. Try not to use too many lengths of wire, because the fewer joins you have, the stronger the armature will be.

2 Use binding wire to join sections of the armature. Holding the two sections together, start to wrap a short length of binding wire around them. Twist it once using your fingers, then more tightly with a pair of pliers.

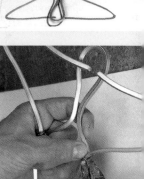

3 Screw an iron support (known as a back iron) to your base board. Attach the armature to the back iron with binding wire, positioning the base of the armature at least 1.5 cm (½ in) above the baseboard.

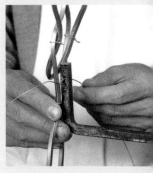

4 To "flesh out" the armature, attach pieces of wood or polystyrene to the framework with binding wire. Wrap binding wire loosely around the armature to help the clay grip. Give the wooden base three coats of shellac to seal it before starting to sculpt.

The shapes beneath the forms

Look for the basic shapes underpinning every form as a way of simplifying the drawing or sketching process.

Paul Cézanne, the famous Post-Impressionist painter, told a fellow painter to "treat nature by means of the cylinder, the sphere and the cone". Years of observation had taught him that everything he saw could be reduced to these three basic shapes. Add the cube and you have taken the terror out of drawing. Using simple shapes to underpin form in a drawing will help you to understand what you see and give you a firm framework for a convincing drawing.

176

Architecture imitating nature

Basic forms in nature (cylinders, spheres and cones) are satisfyingly complete and pleasing to the eye. Small wonder then that architects over the centuries have looked to these natural outlines for design inspiration. Their main challenge was how to construct these forms so they were safe and durable.

Domes (or, according to Cézanne, half-spheres) feature in many constructions. Renaissance architects mastered the art of spanning a space in this way and went on to produce ever more impressive examples of this groundbreaking construction technique.

Cones appear in many guises. Look around next time you are out and see if you can spot any. Record them in your sketchbook.

Modern architects are increasingly innovative in their designs. New building methods and modern materials create exciting propositions that echo natural forms.

177

Nature's geometry

Here's where having a sketchbook really comes in handy. Take it with you and make quick drawings of all the spheres, cones and cylinders that you come across in objects, both man-made and natural. This is good drawing practice to sharpen your powers of observation. Drawing is not just about looking, it's about understanding what you see.

Sphere Cylinder Cone

Cézanne's spheres, cones and cylinders in trees, fruits and vegetables are everywhere you look. A rose blossom is basically a sphere, whereas the canopy of a leafy tree can look domed like an oak or conical like a fir. Find more examples and sketch the underlying shapes.

178 A man-machine

Although not one of Cézanne's natural shapes, you can find the cube in modified forms everywhere. A collection of solid cubes and rectangles constitute the building blocks of the robot figure below. They give it a sense of solidity and power even in the first exploratory sketch. Unleash your imagination and construct your own cyborg from geometric shapes.

3 Added colour is descriptive and not decorative. This is no gentle giant but an awesome, icy-cold and fully functional war machine.

2 The addition of more detail and areas of shading begin to enhance the solidity of the robot. A low viewpoint creates dramatic perspective and adds power and menace.

1 Basic geometric shapes in a balanced arrangement define the robot's superstructure and construction.

179 Virtual gallery

National Gallery of Art
Look at how Paul Cézanne's *Still Life with Milk Jug and Fruit* (1900) uses geometrical shapes such as cones, spheres and cylinders.
http://www.nga.gov/cgi-bin/pimage?52839+0+0+gg84

What do you see in a field at harvest time (above) or in a pile of felled tree trunks (right)? Lots of cylinders, of course, of all sizes and proportions!

The lupin flower (left) is basically a cone. Draw the underlying shape, assess proportions and add details. Next time, comb the beach for seashells (above). Cézanne was right on the money as most objects fit one of three categories: cones, cylinders or spheres.

Having fun with the human figure

Graphic artists have been creating amusing characters and fantasy creatures for decades. Animation and character design as an art form is now big business.

Creating cartoon characters is a blast. To be successful, though, you first need to have a good understanding of the human figure and its basic proportions (pages 15–16). Armed with some knowledge of anatomy, you can create engaging and expressive fantasy characters. Learn how and where the body articulates before you attempt to draw extreme poses or exaggerated figures. There are a few tricks that will help you, but the best way to familiarise yourself with the human figure is simply to draw it a great deal. Take your sketchbook with you everywhere you go and practise drawing figures, poses, gestures, faces, expressions and hands on a daily basis. Sharpen your powers of observation and improve your drawing skills!

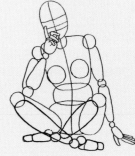

180 Thinking like Cézanne

Paul Cézanne's approach to basic shapes helped pave the way for the work of future abstract artists. Before they could express the body using abstract shapes, however, they had to study anatomical form. Use Cézanne's theory for unlocking the mysteries of the human form (pages 94–95) before attempting to create any cartoon characters. Try this exercise. Look at the human body as an arrangement of spheres and cylinders. Sketch them in the right proportions and position before you "flesh out" your drawing. Use small spheres to represent the articulation points.

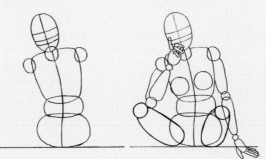

Even a complicated cross-legged pose is less daunting if you search for the basic shapes first. Plot them step-by-step and check proportions as you go.

181 Head-and-body ratios

You must understand real proportion and the differences that gender and age make before attempting to distort the human figure for comic effect.

In adults, the head fits into the length of the body an average eight or nine times, depending on the proportions that are involved. A child's head is larger in relation to its smaller body, about three heads at birth and five heads by the age of eight or nine.

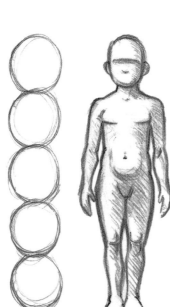

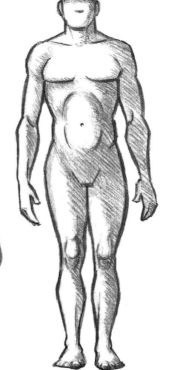

The upper body in the male figure is longer, the shoulders wider, the hips narrower. You'll need to apply some of these telling differences to your cartoon creations.

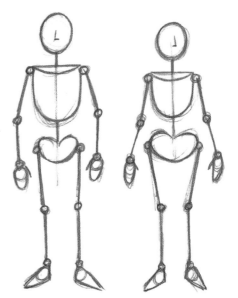

182 Characters on the move

Although you may think stick people are a thing of the past, they are a surprisingly useful shorthand for exploring and expressing movement. Combined with basic anatomical knowledge, articulated line figures distill the essence of action poses to the bone, creating truly dynamic figures.

1 Picture the action in your mind, then decide on the point of balance and the direction of movement.

2 Give your figure weight and balance, even when it's just hanging around on a street corner.

3 Exaggerate the pose, making it as strong and dynamic as possible. Note the location of the articulation points that allow for movement.

183

Fleshing out the bones

Use a selection of building blocks to help you create dynamic action figures. Remember, you'll want to create the illusion of a 3D figure, so you need to draw all of the components in perspective to give a sense of solidity, drama and depth.

Chunky and exaggerated component shapes make this macho soldier as muscular and as powerful as possible.

An invincible superhero is commonly expressed as a caricature with an exaggerated build, a massive chest and enormously oversized shoulders in comparison with the rest of the body.

Developing characters

Getting the body and pose of a cartoon figure right is just the beginning. You also need to inject character and expression into the face and hands.

When we look at a person, we take in the face because no two faces are the same. Similarly, we look at a character's cartoonish face for clues about identity, personality and mood. Getting the body and pose right is obviously key, but a convincing and dynamic character needs to have the right face and the appropriate hand gestures. Observe how real people move and are constructed. Draw them from real life or photographs to gain an understanding of the raw material. Now you can make a successful start on caricatures.

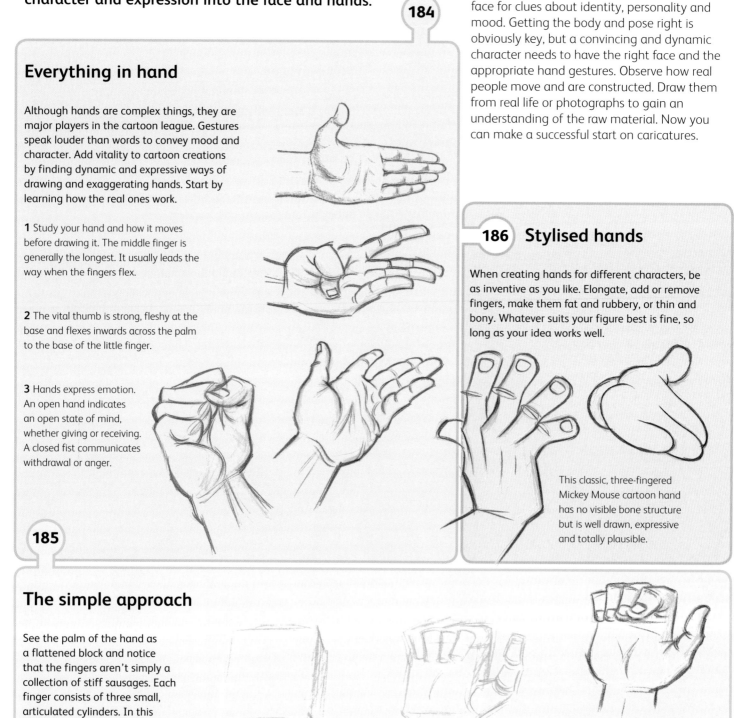

184

Everything in hand

Although hands are complex things, they are major players in the cartoon league. Gestures speak louder than words to convey mood and character. Add vitality to cartoon creations by finding dynamic and expressive ways of drawing and exaggerating hands. Start by learning how the real ones work.

1 Study your hand and how it moves before drawing it. The middle finger is generally the longest. It usually leads the way when the fingers flex.

2 The vital thumb is strong, fleshy at the base and flexes inwards across the palm to the base of the little finger.

3 Hands express emotion. An open hand indicates an open state of mind, whether giving or receiving. A closed fist communicates withdrawal or anger.

185

186 Stylised hands

When creating hands for different characters, be as inventive as you like. Elongate, add or remove fingers, make them fat and rubbery, or thin and bony. Whatever suits your figure best is fine, so long as your idea works well.

This classic, three-fingered Mickey Mouse cartoon hand has no visible bone structure but is well drawn, expressive and totally plausible.

The simple approach

See the palm of the hand as a flattened block and notice that the fingers aren't simply a collection of stiff sausages. Each finger consists of three small, articulated cylinders. In this exercise, try drawing your hand in various positions.

1 Start with a simple block shape which is easy to draw from any angle.

2 Sketch the fingers gripping the palms together.

3 Add volume and detail. The palm and thumb base are fleshy and rounded, while the bony fingers are straight and angular.

187 Structure of the head

Seen from the front, the head is usually egg-shaped and squares off at the bottom. The jawbone attaches to the base of the skull and is the only bit that moves.

1 The eyes are about halfway down the face. The base of the nose is halfway between the eyes and the chin, and the mouth is about halfway between the base of the nose and the chin.

2 In profile, the head is more rectangular. A little more than halfway towards the back of the head, the ears line up with the eyes and base of the nose.

188 Making funny faces

Think of the human face as a circle with an imaginary triangle linking the eyes with the centre of the mouth (right). Try changing the dimensions of the triangle, flattening or elongating the circle (below). The endless possibilities have the potential to create a new character every time!

189 From regular guy to super thug

Ready for some more fun? Remember that a hint of playfulness will help unleash your creativity, loosen up your mind and inspire your linework. Start by drawing a real face, then keep on sketching it, developing and exaggerating different features with each attempt. Repeat the exercise with a female face. Morph her into a she-alien or even a soulful pup. You're the creator, anything's possible!

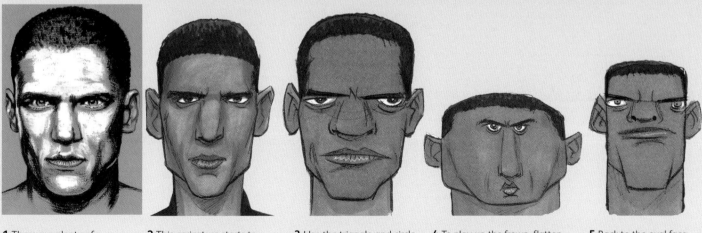

1 There are plenty of elements to manipulate in this good, strong face.

2 This caricature starts to emphasise the eyebrows and set of the jaw. He's starting to look meaner.

3 Use the triangle and circle idea to widen the face and make your character look truly nasty.

4 To play up the frown, flatten the circle and elongate the triangle to concentrate the features in a narrow central portion of the face.

5 Back to the oval face, but this time move the triangle higher up. Mr Nice Guy becomes Mr Mean Machine. Beware!

Techniques

This rich, up-to-date section shows you how to experiment
with using a variety of approaches, tools and media from
monochrome and dry colour to fluid, oil-based and acrylic.
There is also information on putting together a winning
portfolio that could secure you a place with an art college.

Monochrome media

With pencils alone, you can achieve a huge variety of effects. If you add charcoal and conté crayon, you have a full repertoire to suit all subjects.

Pencils did not come into use until the eighteenth century, and then rapidly became the artist's most essential tool. What we sometimes call "leads" are actually made from graphite, a type of carbon mixed with clay and fired in a kiln. The higher the carbon content, the darker the pencil. The relative hardness or softness is marked on the side of the pencil with a number and letter classification. B is for black, with more graphite, and H for hard, with more clay. Having been used more or less since the practice of art began, charcoal is a much older medium than pencil. Sold in sticks of varying thicknesses, it is also available in pencil form. Square-sectioned conté crayons came into use about the same time as graphite pencils and are similar to hard pastels. These can also be purchased in pencil form.

190 Pencils and graphite

If you intend to make finished pencil drawings rather than quick sketches, it is advisable to have several grades of pencil in the B range as well as an HB, which is in the middle of the range. You can't achieve really good darks with anything harder than a 4B pencil, and you may want to use different grades in the same drawing. You might also invest in one or two graphite sticks (thick sticks of graphite without the wooden casing) as these are ideal for covering large surfaces.

▲ **2B and 6B pencils, light pressure**
The amount of pressure you use obviously affects the lightness or darkness of the stroke. Here a fairly light pressure is used.

▲ **2B and 6B pencils, heavy pressure**
Here, a heavier pressure has been used, with lines crossing over one another (crosshatching).

▲ **2B and 6B pencils, blending**
In these examples, the pencil marks have been blended by rubbing with a paper stump to produce areas of solid tone.

▲ **Erasing 2B pencil**
A medium-grade or harder pencil such as an HB can be erased cleanly and easily.

▲ **Erasing 6B pencil**
Soft pencils smudge easily, so learn to keep your drawing hand off the paper, and erase with care.

191 Holding pencils

Most of us tend to hold a pencil as we would a pen for writing – gripping it near the point – but although this gives the maximum control, and is ideal for precise detail, it can lead to dull and inexpressive drawings. It is worth experimenting with different grips: for example, holding the pencil near the end and working standing up enables you to make free, gestural marks.

▲ **Writing grip**
This gives a high degree of control, and is the best choice for precise hatching and crosshatching.

▲ **High grip**
Holding the pencil higher up the shaft encourages you to work more loosely.

▲ **Firm pressure**
Placing your forefinger over the shaft exerts firm, even pressure.

▲ **Underhand grip**
Holding the pencil between thumb and forefinger confines the movement of the tip, so that you must also use your whole hand to make the marks.

192 Combining different grades of pencil

If you are interested in tonal patterns rather than linear marks, use a range of pencils from HB to 6 or even 9B. The best method in this case is to begin with the harder pencils and work up gradually, putting in the darkest tones in the final stages. When using soft pencils, take care not to rest your hand on the paper; if you are working on the top of the picture, cover up the rest with a spare piece of paper.

▲ **Starting the drawing**
The main elements of the composition were sketched in with an HB pencil, then the dark tones of the tree trunk and foliage were built up with 3B and 4B pencils. Notice that the foliage has been left white and carefully drawn around.

193 Linear drawing with charcoal

Charcoal sticks, especially the thicker ones, are mostly used for tonal drawings, but both fine sticks and charcoal pencils are suitable for linear approaches, or a combination of line and tone. Drawings can be built up like pencil sketches by methods like hatching, crosshatching and shading. For this kind of drawing, use either thin willow charcoal sticks or charcoal pencils, as shown here.

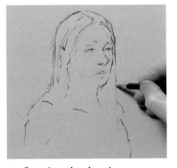

▲ **Starting the drawing**
The artist is working on toned and textured paper that holds charcoal well and allows white highlights to be added in the final stages. He begins with an outline drawing.

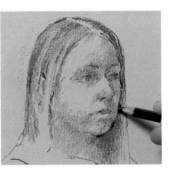

▲ **Shading**
The sitter's face is modelled with light shading. Curving, directional strokes are used for the hair.

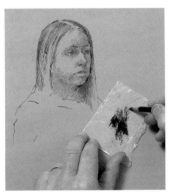

▲ **Sharpening the pencil**
Charcoal pencils become blunt quickly, so a piece of glasspaper is used for sharpening. This method is better than using a knife, which creates dust and can break the point.

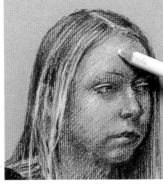

▲ **Adding highlights**
Having built up the face, hair and clothing with darker charcoal applications, the artist can now add highlights to the forehead, lower lip and eyelids. He does this with a white pastel pencil, which has a similar consistency to charcoal pencil.

194 Tonal drawing with charcoal

This drawing features the lifting out technique, which involves removing some of the charcoal with a kneadable eraser to create highlights or light areas. It can be used with graphite pencils, too, but is especially well suited to charcoal as it is easy to remove cleanly. Use smooth drawing paper – textured paper holds the charcoal too firmly.

◀ **From dark to light**
The drawing needs to be worked from dark to light. Having covered the whole of the paper's surface with charcoal, the artist then begins to establish the placing of the ground and the two trees. Using a kneadable eraser, he lifts out some of the charcoal to produce lighter areas.

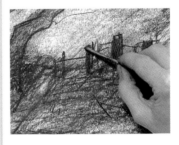

◀ **Adding detail**
Gripping near the end to give a looser, freer line, the artist now uses a thin willow charcoal stick to add linear details.

▶ **Emphasising the lights**
The kneadable eraser is pulled to a point, and more charcoal is removed from the sky area to strengthen the tonal contrasts.

◀ **Tone and line**
While primarily a tonal study, the finished drawing has sufficient linework to create interest and give a feeling of movement.

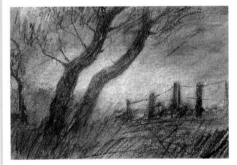

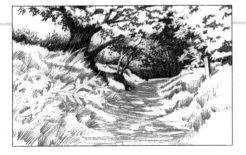

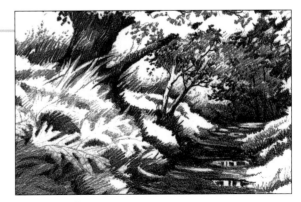

◀ **Moving forward**
An HB pencil was used again to establish the main shapes of light and shade in the foreground. The ferns and sunlit areas on the path have once more been reserved as white paper by drawing around them.

◀ **Balancing tones**
The tones now need to be balanced by bringing in more darks to the foreground. A 3B pencil was used to strengthen the shadows across the path and the midtone areas around the ferns and foliage clumps.

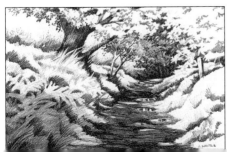

▲ **Final touches**
A 9B pencil, the darkest one of all, was used to make tonal adjustments, notably to deepen the end of the path and take the foreground shadow up the right bank to link both sides of the composition. Finally, puddles were created by drawing dark reflections into some of the white patches.

Dry colour media

Pastels and coloured pencils are known as "dry" media, as opposed to paints, although some of them can be mixed with water.

Sometimes called chalk pastels, soft pastels have a longer history than coloured pencils. Since their introduction in the eighteenth century, they have since undergone a number of changes and developments. They now come in two different grades and shapes – hard(ish), square-sectioned sticks that resemble conté crayons (see page 108), and soft cylinders. Soft pastels are a hugely seductive medium, as they are made from almost pure pigment, with just a little binder to hold the colour together. Hard pastels have more binder in them, as do coloured pencils, which are only sold in stick form and are encased in wood. Both soft and hard pastels must be worked on textured paper because a "tooth" is needed to grip or the pigment to prevent it from simply falling off the paper. Coloured pencils are best on smooth drawing paper.

195 Using coloured pencils

Coloured pencils are a natural line medium but there are other ways of building up solid colour and tone. Traditionally used in pencil drawings, hatching, crosshatching and shading can be used to overlay and mix colours. Broad colour areas are easier with water-soluble pencils – simply lay water over the pencil marks and wash over.

▲ **Hatching and crosshatching**
Hatching simply consists of a set of roughly parallel lines, which may be close together or spaced out widely. In crosshatching, another set of lines crosses the first in the opposite direction.

▲ **Varying marks**
Hatching and crosshatching lines can be quite varied and free – almost scribbled – and different colours can also be laid one on top of the other.

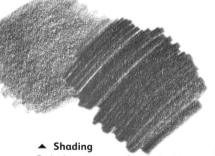

▲ **Shading**
To shade an area, move the pencil point evenly across the paper. This example shows even, lightweight shading and heavy, directional shading.

▲ **Water-soluble pencils**
These can be used either dry, like conventional coloured pencils, or spread with water to form washes, as here.

196 Overlaying colours

However large your set of coloured pencils (and don't buy a lot until you are sure that you like the medium), you will always have to mix colours to some extent. Most coloured pencilwork depends on the effect of overlaying pigments to achieve richness of hue, tonal density and three-dimensional modelling.

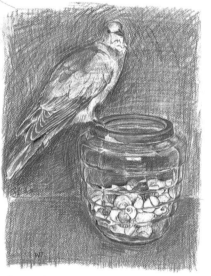

▲ **Mixed hues**
Overlaid patches of shading produce subtle mixes and colour gradations. This sample contains four colours: yellow, yellow ochre, green and grey-blue.

▶ **Working freely**
The heavy grain of the paper encourages a bold approach, with the colours overlaid freely using loose hatching and shading techniques. Notice how the curved hatching strokes in the background follow both the forms of the bird and the glass vessel.

◀ **Brilliant effects**
Several layers of water-soluble pencils in pink, yellow, orange and red have been used to build up colour intensity. The pencil marks have been washed over with water on the leaves and some of the petals.

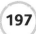

(197) Markmaking with pastels

Pastel is both a drawing and a painting medium. Whether you choose hard or soft pastels – or both – depends very much on the work you want to do. Soft pastels are the best for creating painterly effects, with colours laid over one another, while hard pastels and pastel pencils are more suited to linear approaches. However, hard pastels are often used in the early stages to lay in the first colours because they don't smudge so easily and provide a fairly solid basis for laying soft pastels on top.

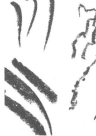
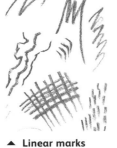

▲ **Linear marks with soft pastel**
Soft pastel typically produces blunter lines than hard pastel or pastel pencil.

▲ **Linear marks with hard pastel**
If you intend to make line drawings rather than paintings, hard pastels may be a better choice.

▲ **Linear marks with pastel pencil**
Pastel pencils are excellent for drawing and sketching, and can also be used to add detail to the final stages of a pastel painting.

▲ **Side strokes**

The best method for building up an area of colour quickly, these strokes can be made with both hard and soft pastels. Simply draw the long side of the stick (you may have to break it in half) across the paper in any direction you choose. Tones and colours can be built up by laying more strokes on top.

(199) Blending pastels

Because pastel is so soft and crumbly, it is very easy to blend strokes into one another to produce continuous areas of tone, or to rub colours into one another to mix them. Blending is an important technique in pastel work, and can be done with a rag, brush or for smaller areas, a finger or paper stump.

▲ **Applying the first colours**
Apply the first colours lightly, without pressing into the paper, then go over them with a rag or the flat of your hand. This will remove some of the pigment, but more can be added later.

▲ **Adding a second layer**
Apply more colour with the side of a pastel stick, avoiding pressing heavily. You should be able to see the grain of the paper through the marks.

▲ **Building up**
Continue adding colour and blending until you have the right depth of hue. Use the rag or another blending implement in a directional manner to help you build up the forms.

▶ **Contrasting methods**
Take care not to blend all over the picture, as this can produce a rather bland effect. In this painting, the rich colours of the clouds were achieved by hand blending. Less blending was done at the bottom of the sky and the linear treatment of the grasses provides a good contrast to the softness of the clouds.

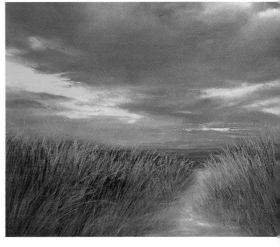

(198) Coloured grounds

Pastelwork is nearly always done on coloured paper for two reasons. First, the pastel never covers the paper completely unless used very heavily. If white paper is used, you will see little flecks of white between strokes. Second, you will often want the hue of the paper to show through and contribute to the overall colour scheme. Dramatic effects can be achieved by working on dark paper but, to begin with, it is best to stick to neutral, midtone papers.

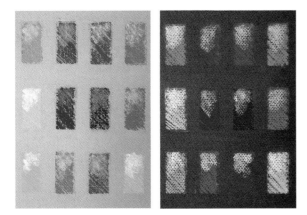

◀ **The effect of the paper**
The hue and tone of the paper dramatically influences the effect of any applied pastel colour. Notice how the lighter colours appear much more vibrant against the dark paper than on a midtone sheet, and how the darker colours virtually disappear because their tone is similar to that of the paper.

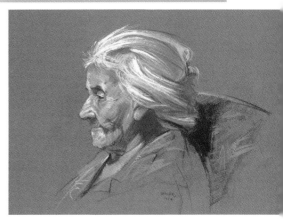

▲ **Leaving the paper bare**
Known as vignetting, this technique involves deliberately leaving large areas of the paper uncovered, so choose the paper tone with care. The warm colours and pale tints of the sitter's face stand out against the deep blue-grey background, and the paper colour itself has been used for the darker areas of the hair.

Fluid media

Watercolours and drawing inks can be used on their own, or combined with one another for powerful effects.

Watercolour is sometimes regarded as an old ladies' medium – delicate and fragile – but, in fact, it has been exploited by many major artists, both past and present. Think of Winslow Homer and Georgia O'Keefe, for example. It is not an easy medium to master, partly because it can be unpredictable, and also because you can't make corrections by overpainting as with an opaque medium. Watercolour is transparent and must be worked from light to dark. One of its many delights is that it can be combined with other media, such as coloured pencils, pastels or coloured inks, as shown here.

200 Watercolour washes

Large or small, washes are the basis of all watercolour work, and are usually defined as an area of colour that cannot be achieved with a single brushstroke. Although you may never need to spread an even wash over the entire surface area of your paper, do practise this technique as it will help you to get a feel for this medium.

201 Working wet-in-wet

Here you can start to have fun with your paints. New, darker colours dropped onto still-wet washes spread out and dry with soft or sometimes jagged edges but beware of working on very wet paper as the colours will simply continue to spread until dry, leaving you with nothing much more than a wash. Be patient and wait until the sheen is off the paper before adding new colours.

▲ **Wash on damp paper**
If you want the wash to cover all of the paper, dampen with a sponge first, then lay a horizontal band of colour across the top. If you want the wash to cover only part of the paper, avoid dampening it or the colours will run where you don't want them to.

▲ **Colours will merge**
Work down the paper in the same way, letting each band of colour just touch the one above it so that all of these "stripes" merge into one another.

▲ **Painting clouds**
A pale blue wash was laid in first and allowed to slightly dry before first deep indigo and then red were dropped in.

▲ **Suggestive effects**
The colours have merged in such a way that suggests patterns rather than gives a literal description of what a stormy sky looks like.

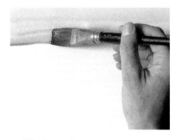

◀ **Graded wash on dry paper**
A graded wash is lighter at the bottom, which is useful for skies. Work on dry paper and start with a strong band of colour. Dip the brush in water to dilute the pigment first before laying in the next band, and continue in the same way. If you want a stronger transition between tones, simply dip the brush in water twice each time.

◀ **Working wet-on-dry**
In this painting, the dark colours of the cow and the foreground grass were built up gradually by laying a series of wet washes over earlier washes that had been allowed to dry.

▲ **Exploiting backruns**
These are happy accidents and can spoil a perfectly good wash but, like many watercolour effects, can be encouraged and used to advantage. They happen when a lighter colour, or simply water, is dropped into a darker one.

▶ **Abstract shapes**
Deliberately induced backruns make a pleasing abstract pattern in the immediate foreground, where some extra interest was needed to balance the flower shapes.

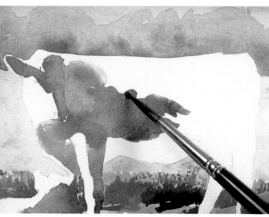

202 The power of the paper

In watercolour work, highlights are achieved by "reserving" areas of the paper, that is, by painting around them. Small highlights can in fact be added with opaque paints like gouache or acrylic, but these are nowhere near as brilliant as pure white paper. White paper plays a vital role in watercolour painting, as it reflects back through the layers of transparent colour to give a lovely translucent effect.

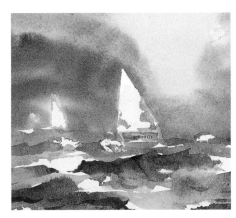

▲ Painting around dry shapes
The artist has reserved the white flowers by painting around them. Because she wanted to work loosely wet-in-wet on other areas, she dampened the paper around the flowers, leaving the shapes themselves as dry paper – paint will stop when it meets dry paper.

▲ Brilliant whites
With the darker flower and tray areas painted in, the pure whites on the tops of the petals and the lightstruck area on the tray shine out, giving a lovely evocation of sunlight.

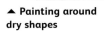

◀ Masking highlights
Liquid frisket – or masking fluid – is an artist's best friend when it comes to highlights. It can be painted on before colour is laid in, and removed in the final stages to reveal white paper. Here the artist has used the fluid as a way of "painting in negative", making a series of imprecise but suggestive shapes that give the painting a sense of movement and drama.

▲ Masking before painting
For this picture, the poppies have all been masked while the grass was painted. Masking out shapes before repainting them is a common use of liquid frisket. Imagine how long it would have taken to paint all around these small shapes.

203 Inks, pens and markers

Pen and ink are often used with watercolour in an established technique called line and wash. There are many different drawing pens available, one of the most useful being the dip pen which can take a number of different nibs. Drawing inks come in two main categories: waterproof and non-waterproof. Available in a wide range of colours, acrylic inks are classed as waterproof; although they can be mixed with water, they are impermeable once dry. True water-soluble inks will soften when brushed over with water even when dry. Markers, which hold their own reservoirs of ink, are also made in these two categories.

◀ Line and wash
In this expressive painting, the artist has used pen and ink freely, without any attempt at precision, in order to fully integrate both linear and watercolour elements.

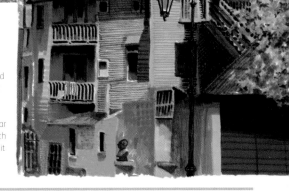

▶ Brilliant colours
Made with wedge-tipped and pointed markers, this vibrant drawing has been built up gradually, from light to dark, as in watercolour work. Similar effects could be achieved with brushes and acrylic inks, but it would be more difficult to achieve straight lines.

204 Brushwork

The marks of the brush can play an important role in watercolour work, though some artists dislike obvious brushwork. Experiment with different brushes to discover which is the best for the job in hand, and try to make the marks describe the shape you are painting. For example, foliage can usually be rendered in a series of one-stroke marks made with the point of a round brush, as can the ripples in water. Flat brushes are useful for linear strokes because they can be held on the sides as well as at their full width.

▲ Loosening up
To avoid your brushwork becoming tight and fussy, hold the brush near the top, or work standing up so that you have to make wrist movements instead of just moving your hand.

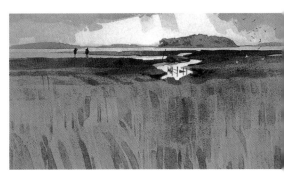

▲ Aids to composition
In this painting, the brushwork made with a flat brush serves two purposes. First, the near-vertical and slightly curving strokes describe the grasses, and second, they provide a balance for the horizontal emphasis of the composition.

Oil-based media

With its own body of techniques, oil paint is one of the older painting media, but twentieth-century inventions like oil pastels and oil bars invite experimental work.

The Flemish painter Jan van Eyck is credited with inventing oil paints in the early fifteenth century, and their popularity spread rapidly to become the foremost painting medium in the Western world. As artists found new methods of working, styles changed over the centuries, as they still do today. Oil paint is not liked by everyone – it is rather messy, and some people are allergic to the turpentine used to thin it – but to other artists this thick, creamy medium and its smell are very seductive. Oil pastels and oil bars (sometimes called paint sticks) have been around for some time, but manufacturers have responded to their joint popularity by continuing to develop them and increasing the colour ranges. Both media can be used on their own or with conventional oil paints.

205 Fat over lean

Oil paint with a high percentage of oil, or which is used straight from the tube, is described as fat, while paint thinned with turpentine or mineral spirit is lean. In a painting that is to be built up in layers, it is vital to start with lean paint because if you apply thin paint over thick, the top layer will dry before the lower one, causing cracking.

▲ **Fat and lean paint**
The blue paint has been thinned with turpentine, whereas the red paint is from the tube and has a more solid consistency.

▶ **Building up**
The painting is continued using paint thinned with a half-and-half mixture of turpentine and linseed oil.

▶ **Underpainting**
The composition and tonal structure is established using lean paint. An advantage of this is that non-oily paint dries quite quickly, so you don't have to wait long before adding another layer.

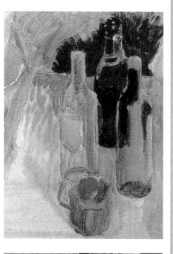

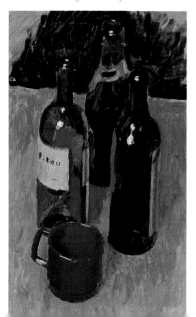

◀ **Thick highlights**
In the final stages, thick paint straight from the tube is applied directly to the highlights. Always use thick paint for areas you want to emphasise, as it has a stronger physical presence than thin paint.

206 Working *alla prima*

This phrase means "at first" in Italian and describes paintings that are completed in one session rather than being worked in successive layers. The first painters who worked outdoors – Constable, Corot and later the Impressionists – established this approach as an acceptable technique, and since then the majority of oil painters have worked in this way for all subjects from landscape to portraits and still life.

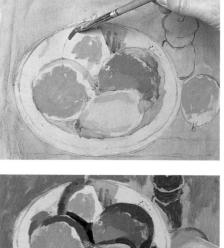

◀ **Establishing the composition**
Ellipses are difficult to get right, so they were first drawn in pencil before the main shapes and colours were blocked in. Thin, fast-drying paint was used for the tablecloth, so the other colours could be laid on top.

◀ **Darker tones**
Midtone colours have been painted loosely over the tablecloth, and now the deep tones of the fruit, shadows and salt grinder are added in.

◀ **Centre of interest**
The red stripe around the plate is painted next. It is vital to the composition because it helps to establish this as the main centre of interest.

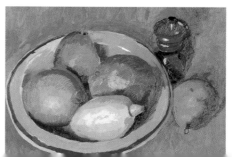

◀ **Highlights**
These are vital, not just to create interest and give sparkle to the work, but to define shapes and forms. A fine sable brush with undiluted paint is used to paint in these highlights with great precision.

(207) Glazing

Although less used now than in the past, glazing can produce wonderful effects. Renaissance artists would paint in a series of layers, usually over a monochrome underpainting, so that one colour would shine through another to achieve vibrant combinations. You will need a special oil-paint glazing medium that makes the paint more transparent. In this popular acrylic technique, either an acrylic medium or water can be used – the method is the same for both media.

▲ Planning
The composition was drawn carefully and a yellow underpainting laid over the canvas, leaving the bright highlights on the fruit as white.

▲ Wiping off
With the paint still wet, some areas are removed by wiping off previous glazes with a cloth.

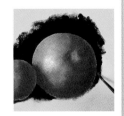

▲ Letting it dry
Oil-paint glazes must be applied over dry paint. The painting was left to dry for a week, then further glazes were used to build up the fruit before the background was painted above them.

▶ Finishing touches
Once the dark background surrounding the oranges was completed, and the tabletop finally painted, the reflection was applied to the wet paint and blended in using a brush.

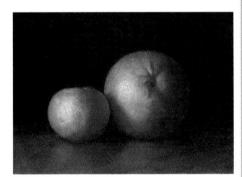

(209) Impasto

This term describes paint that has been applied thickly enough to retail the ridges and textured marks left by the brush or painting knife (see also knife painting with acrylic on page 112). Most often, impasto work is confined to areas that need to be emphasised and left until the later stages, but some artists like to work in this way from the outset.

▲ The picture surface
Claude Monet believed that the surface of the picture was as important as the subject. This artist shares his opinion, building up the painting with decorator's knives and often his fingers to produce a wonderful variety of textures.

▲ Knife marks
Creating a very different effect from that of brushes, knives squeeze the paint onto the surface of the paper, producing flattened areas and high-relief ridges.

▶ Selective impasto
This picture has been painted relatively thinly overall, with impasto touches reserved for the waves, clothing and immediate foreground.

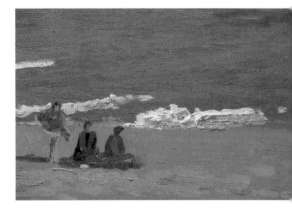

(208) Transparent and opaque

Oil paint is basically an opaque medium, but many of the pigments used are transparent or semi-transparent until mixed with white. Some artists combine the qualities of both transparent and opaque paint, moving imperceptibly between the two, while others exploit the natural thickness of the paint right from the start.

◀ Using thin paint
White has been used in this painting, but the mixtures have been thinned out considerably to achieve translucent effects reminiscent of those in Turner's landscapes.

◀ Brushwork
Thick paint allows you to exploit the marks of the brush, which play a major role in this artist's work.

(210) Oil pastel and oil bars

Paint sticks and oil pastels are robust and encourage a bold approach. Oil pastels may be used like chalk pastels but cannot be blended with a finger or rag, although you can "melt" the marks with solvent and mix them on the paper with a brush. As with oil paints, paint sticks can be layered and combined with conventional oils.

▲ Broad effects
Best for bold, large-scale work, paint sticks are quite chunky. Colours can be mixed by overlaying.

◀ Blending sticks
Used with both paint sticks and oil pastels, these colourless bars are made for blending. Rub over your work to smooth out colour and make it more transparent.

◀ Dowsing the paper
The surface has been wetted with mineral spirit first, making the oil pastel glide over it easily, and helping the second colour to blend with the first.

▼ Oil pastel blending
Laid onto paper, oil pastels are then blended with a brush dipped in mineral spirit.

Acrylic techniques

The newest of the painting media, acrylics are highly versatile and exciting to use.

A byproduct of the plastics industry, acrylic paints did not come into use until the middle of the twentieth century. They are frowned upon by some die-hards, who regard them as nasty plastic paints but, although the binder is a form of plastic, most of the pigments used are the same as for oils and watercolours.

Acrylics are capable of a huge range of different effects and invite experimental approaches. Unlike oil paints, they have no smell and require no medium other than water (as they are water-based), except those used for special effects.

211 Different consistencies

Acrylics can be used thinly like watercolour, at medium consistency, or thickly like oils. Indeed it is sometimes hard to differentiate an acrylic painting from an oil-based work. Acrylics are much more than simply an imitative medium; they have their own special qualities and you can do things with them that you can't with any other medium.

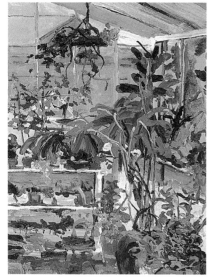

◀ **Using thin paint**
As long as you don't add white, the paint will be transparent. In this painting, the thin paint creates a watercolour effect.

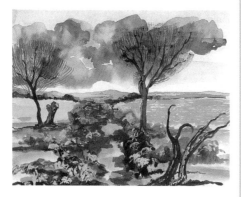

▲ **Oil paint effect**
Painted on canvas with bristle brushes and thick paint, this painting would be difficult to distinguish from an oil-based work.

Glazing
Originally an oil painting technique but now much used in acrylic painting. The method is the same for both media, except that for acrylics, the medium used for thinning the paint is a matte or gloss medium, It is less time-consuming to glaze with acrylics, as each colour layer dries fast, whereas with oils you have to wait several days for each glaze to dry.

Impasto
Also demonstrated under oil paints. The method is the same but for acrylics you would need to thicken the paint with either a heavy gel medium or texture paste.

▲ **Combining thick and thin paint**
Although the paint has been used as watercolour at the top of the picture, it has been built up thickly at the bottom.

212 Using mediums

Although water is the primary medium for acrylic, many different mediums are produced for changing the nature of the paint, making it thicker, thinner or more transparent. The most commonly used for thin or medium-consistency applications are matte and gloss medium, which can be mixed with the paint plus a little water.

1 Gloss medium
Thins and makes paints more transparent, so they can be built up in layers. Mainly used for glazing.

2 Matte medium
Similar to gloss medium but slightly thicker, it can also be mixed with the paint or used for glazing if you prefer a matte surface.

3 Gel medium
An exciting medium as it thickens the paint without reducing its transparency.

4 Texture paste
Also known as modelling paste, this very thick medium is designed for heavy impastos and special texture effects.

5 Retarding medium
Acrylic dries really fast, so if you want to work wet-in-wet as oil painters do, this is a must because it slows the drying time so that colours can be blended.

213 Interference medium and colours

These two paintings are in fact just one painting and not two different versions of the same subject. The artist has used interference colours, which contain tiny particles of mica that reflect light in different ways. Colours have been used both as a transparent medium and for overglazing. Interference mediums, which you can mix with the paint, will create similar effects.

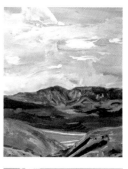

Changing effects
If you were to see these paintings side by side, you would see little or no difference. If you took one off the wall and moved it somewhere else, this would change, as it all depends on the direction of the light.

Angle of viewing
Here the photograph was taken with the painting opposite the light source, whereas the other image was taken with the painting placed halfway between two light sources.

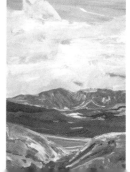

214 Working wet-in-wet

Basically an oil painting technique, wet-in-wet can be adapted to acrylics. When two brushstrokes of wet paint meet or overlap, the colours blend into each other. When using fast-drying acrylics, adopt one of two strategies to keep the paint moist: either use a retarding medium or dampen the working surface before you begin, continuing to spray it from time to time. Don't mix the two methods as water affects the performance of retarding medium and, if you use the latter, don't add water to the mixes – use the paint at tube consistency.

▲ **Blocking in**
Thinned paint is used for the background. The teapot is then painted with various dark colours mixed with retarding medium and allowed to blend.

▲ **Building up**
The same method is used for the fruit – rich, deep red is applied over orange using a bristle brush. This type of brush is the best to use as it pushes each new colour into the previous one.

▲ **Highlights**
The paint is allowed to dry before pure white is added with a small brush for crisp and clear highlights.

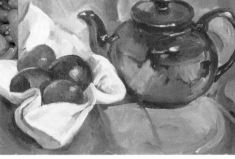

▲ **The necessity for speed**
The artist worked fast, because the retarding medium only keeps the paint workable for about half an hour, depending on the thickness of the paint that is used. The water-spray method would give you more time, but not enough for a coffee break.

216 Tonal underpainting

Using a monochrome underpainting to establish the basic drawing and tonal structure is one of the many techniques borrowed from oil painting, but it is less used by painters today than in the past. Acrylic, however, is ideal for the method, as you don't have to hang about waiting for the underpainting to dry before adding in the colour.

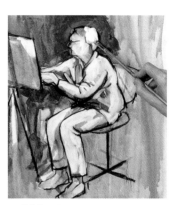

▲ **Brush drawing**
The method is best for a painting that is to have a strong tonal structure. The artist begins with a brush drawing in diluted black paint to establish the main shapes.

▲ **Adding tone**
Darker tones are laid in the background, and the figure is built up in light grey overlaid with thicker applications of white, which will allow for glazes of light and bright colour.

▲ **Letting the brushmarks show**
Red paint thinned with water is now applied over the thickly applied white. Notice how the earlier brushmarks show through to model the forms.

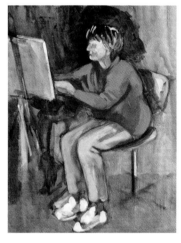

▶ **Thin over thick**
In oil painting, you can't lay thin colours over thick ones, but in acrylic you can. All the top colours have been used thinly here so that the underpainting shows through.

215 Dry brush

This is a technique used in all the painting media, whether transparent or opaque, and can achieve attractive broken-colour effects. A good method for imitating certain textures, dry brush simply means working with the minimum amount of paint on the brush, so the colour below is only partially covered.

▲ **Coloured ground**
Disliking working on white, the artist has begun by painting the ground a diluted ochre. This pigment will play a major part in the finished picture. He lightly scumbles over the yellow with white and off-white.

▲ **Texture effects**
The crusty loaf is accurately rendered with successive dry brush applications.

▲ **Colour variations**
Considerable variations of colour and tone have been achieved on the breadboard by layering one colour over another.

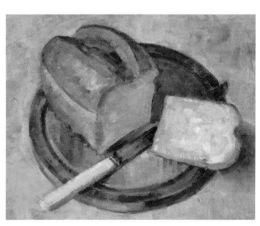

▲ **Consistency of approach**
The dry brush method can be used for certain areas of a painting. In this case, the artist has produced a well-integrated image, both through the consistency of his technique and use of a limited colour palette.

Experimental techniques 1

Try out new techniques and have fun with your materials to discover how to give your work that extra wow factor.

The techniques shown on these two pages are mainly concerned with building up exciting surfaces, which are just as important as the subject. Some of the techniques, such as spattering, can be done with any painting medium, so you will be able to adapt them to your favourite, whereas others are media specific.

217 Painting with knives

Oil painters have used painting knives for centuries, usually with traditional brushes, but whole paintings can be built up using knives. Painting knives come in different shapes and sizes, in both steel and plastic (use the cheaper plastic ones to try out the method), and can produce surprisingly delicate effects as well as dramatic impastos. In these examples, acrylic is used but the method is the same for oils.

▲ **Applying paint**
Mix the required colour on your palette, scoop it up with the base of the knife and apply as you would plaster a wall or ice a cake.

▲ **Mixing**
Use the knife to remove paint that is still wet to create interesting textures. To vary the marks, use the point, sides and edge of the knife.

◀ **A long-bladed knife**
To establish broad areas of colour quickly, use a painting knife with a long blade. It is best to begin with a fairly thin application and build up when the first layer has dried.

219 Scraping off

Another form of knife painting, this method produces flatter layers that cover the surface more thinly. It is ideal for layering techniques in which thin paint is scraped over thick paint, and vice versa. You don't have to use painting knives – old credit cards and wallpaper scrapers work fine. You can use this method with either oils or acrylics.

▲ **Using a credit card**
A layer of blue is laid first, followed by a darker colour, which is now scraped sideways with the card. Although the acrylic paint is used at tube consistency, the coverage is thin enough to reveal the colour beneath.

▲ **Using a wallpaper scraper**
A metal scraper gives more rigidity than a plastic card, producing thicker, more irregular coverage that is now exploited to build up surface texture in places.

▲ **Varying the direction**
The card is used again, this time to pull transparent colour downwards and describe the reflections at the bottom of the picture.

▲ **Unusual effects**
Instead of dragging it across the surface, use the card to apply the paint in a series of short, interrupted strokes..

218 Sgraffito

This technique involves scoring into paint with a sharp implement to reveal either the colour of the ground or another colour underneath. This method can be used with oils or acrylics but, in the latter case, you may need to use a retarding medium to keep the top layer of paint moist. Scratching into fully dry paint will give only white lines as all the layers of paint will be removed.

▶ **Revealing an underlying colour**
In this acrylic painting, the artist begins with a red underpainting, which is then overlaid with various blues and blue-greys. These are scratched away with the point of a craft knife to produce a pattern of red lines.

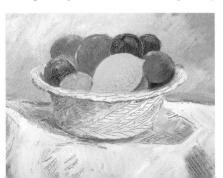

▶ **White lines**
The impact of this oil painting comes from the thin white lines produced by scratching into dry paint to reveal the white ground. In the background, a subtler effect was gained by scratching with a paintbrush handle into a still-wet layer of yellow laid over a lighter one.

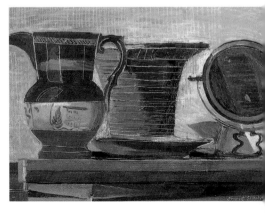

220 Acrylic texturing

Acrylic excels in creating texture – there is almost nothing you can't do with it. You can create texture with the paint itself by mixing it with sand, sawdust and other materials, or you can lay underlying textures with modelling paste, which is specially made for this purpose. It is essential to work this technique on a rigid surface; if applied to paper or canvas, the paste will crack.

▲ Imprinting
Modelling paste has been spread all over the board, first with a palette knife and then with a steel comb. A coin is now pressed into the paste to make an imprint.

▲ Building up textures
Bubble wrapping produces an interesting imprint. Each area of texture is kept separate, creating what is in effect a series of motifs.

▲ Applying the paint
Once the paste dries, the whole surface is first sprayed with acrylic ink using a spray bottle, and then red acrylic is applied. Thicker blue is now painted onto selected areas. Notice how it catches only on the ridges of the texture.

▶ Colour mixing effects
The final stage, which transforms the whole image, is to spray yellow acrylic ink over the whole surface. Similar to a colour glaze, the yellow mixes with the red and blue to produce subtle shades of orange and greenish blue.

221 Salt spatter

One of the most exciting ways of creating texture, surface interest or both, this method can only be used with watercolour or water-soluble inks. If you scatter rock salt crystals into still-wet paint, they will absorb the pigment gradually, drawing it into each crystal to produce a snowflake effect. The effects vary according to the wetness of the paint and how thickly or thinly the crystals are scattered, so feel free to experiment with this technique.

▲ Starting with washes
Loose washes of several colours are laid wet-in-wet, and allowed to slightly dry until the sheen comes off the paper. The salt is scattered thickly and closely.

▲ Be patient
It takes salt quite a long time to absorb all of the paint, so set your work to one side and do something else for an hour or two. The result is worth waiting for.

▶ Suggested texture
The salt spatter has been cleverly integrated into the landscape, so it does not stand out too much and suggests texture without being literally descriptive.

222 Spattering

Flicking or spattering paint on the surface is a quick and direct way of adding interest to an area of colour. It can suggest texture or landscape features, such as pebbles on a beach or flowers in a field. The method can be used with any painting medium or diluted inks. If you are spattering a specific area, mask the rest of the painting with masking tape or torn pieces of paper, as the method is not controllable.

▲ Spattering over a base colour
You can spatter directly onto white paper, but usually a base colour is dropped in first. When this is dry, lay the work flat, mix your desired colour and thin it with water so that it leaves the brush easily. Dip the brush, hold it over the work and tap the handle sharply with your free hand to release droplets of colour.

▶ Complex spatter
To achieve lively areas of broken colour, repeat the process as often as necessary. Vary the size of the droplets by altering the consistency of the paint.

▲ Spattering wet-in-wet
If the surface of your paper is wet, slightly spattering thicker paint onto it will make the pigment spread out and diffuse, creating soft effects. This could be useful for foliage.

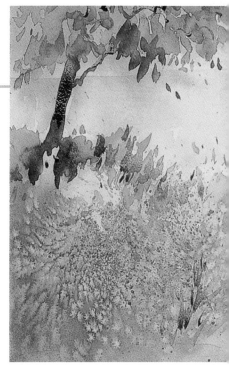

Experimental techniques 2

Have fun with your materials and learn by trying out new methods.

The methods shown on these pages are intended to give you ideas that you can pursue in your own way and adapt to your chosen subject. Most of them are the results of individual artists experimenting with different ways of working and trying out various mixed media approaches. There are no hard-and-fast rules for mixed media work: almost all the drawing and painting media can be used in combination, but some are more successful than others.

223 Conté and oil bar

This is an exciting way of manipulating any dry drawing media (see page 104) so that it behaves more like paint, and can be moved around on the paper. You will need a colourless oil bar or blending stick, and whichever drawing medium you like to use – soft pencils, conté or coloured pencils will all work well. You begin by scribbling all over the surface with the oil bar, which will turn the pencil or crayon into a soft paste.

▲ **Making the mixture**
The artist is working on oil sketching paper. Its non-absorbent surface makes it easier to move the conté and oil mixture around. Having covered the surface with the oil bar, he makes a light drawing and then rubs it into the oil bar with a rag.

◀ **Building up**
After adding more line and tone, the artist rubs in more of the oil bar. This picks up some of the colour (useful for lifting out highlights). Another layer of conté and oil bar is added on afterwards and the tonal intensity is reduced by scraping back with a palette knife.

224 Ink and gouache wash-off

This basically simple but rather time-consuming method produces an effect rather similar to a woodcut. It exploits the properties of waterproof ink and water-soluble gouache paint, which is to produce a black-and-white image that can either be worked into and developed with colour, or left as it is. You will need tough, heavy paper for this technique as it will have to be immersed in water.

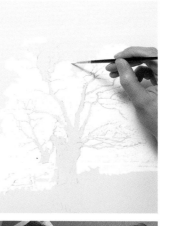

◀ **Making the drawing**
The artist begins with a careful drawing and then lays a yellow wash over the whole of the paper so that he can see where to place the white. He now paints on white gouache in the areas that are to remain white.

▲ **Inking up**
Black waterproof ink is applied over the whole of the image. This must be done very carefully, strip by strip.

▲ **Washing off**
The paper is held in a bowl of water and the ink carefully removed with the aid of a cotton ball. Because gouache paint is water-soluble, only the uppermost ink is removed.

▶ **Accidental effects**
This method is never entirely predictable, which adds to its charm. In this case, the ink has broken up slightly and not been fully removed from the white areas. The effect, however, is nevertheless attractive.

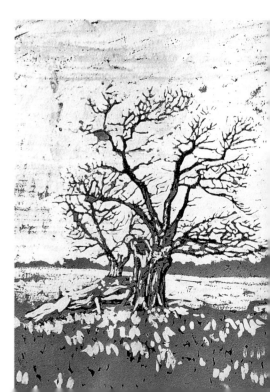

225 Monoprinting

Monoprinting is an exciting method of making one-off prints that require no printing press. There are many different methods for both monochrome and colour monoprints, but the one shown here uses oil paints combined with oil pastels. You can also use either water-soluble printing inks or acrylic for the initial painting but, in the latter case, you will need to use a retarding medium to keep the paint workable for long enough to take the print.

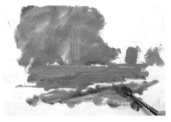

▲ Painting the design
Use a non-absorbent surface for this first stage. The artist here is working on glass. He paints the design onto the glass, using slightly diluted oil paints and keeping the colours separate – if colours are overlaid, only the topmost one will print.

▲ Taking the print
Having placed a sheet of thin drawing paper over the printing surface and rubbed all over it with his fingers to encourage the paint to adhere, the artist lifts it off carefully by one corner.

▲ Working over the print
Oil paint monoprints usually come out quite pale and require some overworking to add emphasis. Here, oil pastel is used to draw loosely and freely into areas of the trees and foreground.

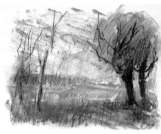

▲ Print qualities
The artist takes care not to add too much of the oil pastel, so as not to sacrifice the print-like qualities.

227 Collage

Sticking pieces of paper or other flat objects onto paper has always been a popular play activity for children, but since the early twentieth century, it has also become a fine art technique. There are no real rules for collage work, and the possibilities are almost limitless. Almost anything that can be stuck down can be used, from pre-coloured papers and pieces torn from newspapers and magazines to dried leaves and pieces of grass. Collage is especially well suited to acrylic work, as acrylic mediums have strong adhesive qualities.

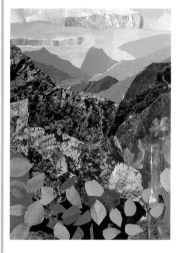

◀ Cut and torn paper
Different materials and methods are combined in this image. The mountains are torn coloured paper, cutout shapes have been used for the foreground, and images from magazines were used for the light-coloured foliage.

▶ Tissue paper collage
This artist uses the collage element as a first stage, gluing acid-free tissue paper onto the painting surface with an acrylic gloss medium. Over this texture, she has poured and painted acrylic glazes, followed by a light application of gold and sliver oil pastels and then more paint.

226 Ink and bleach

This is an exciting though unpredictable technique that involves drawing with brushes and household bleach into water-soluble black or coloured inks. Don't use either acrylic inks or shellac-based ones, as these can't be removed. You will need to experiment because sometimes even diluted bleach can remove more ink than intended – and don't work in a carpeted area as any drips could ruin a carpet!

▲ Varying the tools
The whole of the paper is covered with ink, and areas are now lifted out first with a brush, and then a bamboo pen, which produces fine white lines.

▲ Varying the colours
After adding some details with black permanent ink and making more white lines with the bleach and pen, the artist lays another wash, this time with blue ink.

▲ Building up effects
Areas of blue ink have been removed with the brush and bleach. Draw into the wet ink and bleach mixture with the bamboo pen.

▶ Exploiting effects
Finally, the building is defined with the brush and pen. The artist exploits the bleach's tendency to produce yellow rather than white for a strong sense of drama.

"We see hundreds of portfolios, thousands of pages and ten thousand images. What I am looking for is something to stop me leafing through the pages, something that surprises me and makes me want to look further at this student's work."

Alan Baines, Course Director BA Graphic Design at Central Saint Martins College of Art and Design, London

Note: every college looks for something slightly different in its applicant portfolios. The following pages are case studies from Central Saint Martins College of Art and Design, University of the Arts London. They were chosen because they show strong individual personality and a diversity of approach. This particular course looks for signs of deep thinking beyond the usual surface skills that other courses may encourage.

Creating your portfolio

An art school portfolio is an important tool for assessing your true potential as an art student. The practical suggestions and examples included in this section will help you to achieve your goal. A portfolio is a visual representation of who you are as an artist. It's a visual snapshot of your potential as an aspiring art graduate, so think carefully about what you put in it. Art colleges look for a variety of skills in prospective students. They want to see evidence of a creatively fertile and inquiring mind. There is no typical student as individual development is key. They want to see that you have the potential to develop on the course and are open to new ideas, that you experiment with new materials and new forms of expression. Include work that shows ideas in development, as well as finished projects. Your sketchbooks are an important clue to the way you think and work, so include several of these and take photos of 3D work.

The application process

Take time to research online the colleges or universities you would like to apply to. Do they have the course you would like to take? Does the content and structure of the prospectus sound interesting and in line with the direction in which you wish to develop?

Read through the admissions procedure of a particular college. You will be required to fill in an application form and you will need to have certain academic qualifications. Generally, it is preferable to send portfolios for viewing. The admissions information will tell you how to do that, depending on the college's particular requirements. Portfolios with sketchbooks are preferred as these provide a visual control for all applicants and your work is viewed in its original form. It is also easier for a committee to look through and assess portfolios, rather than viewing work on screen. However, due to distance or

The traditional spiral-bound, loose-leaf portfolio (above) is available in different sizes and qualities of cover. Don't be lured into thinking that to make an impression, you have to have a big portfolio. If your work is small and you find that seventy-five per cent of the portfolio shows just the mount (unless the space is part of your concept), use a smaller portfolio. It will be easier for the colleges and cheaper for you. Always label your portfolio and each removable page with your name.

This photo-archive box portfolio (above) allows for loose leaves to be taken out. It has a professional feel as the work is protected by acetate sheets. The student (left) decided that a tactile approach would benefit his work. The loose pages don't need acetate protection as they have textural interest.

Check that it is acceptable to present your work digitally. If e-mailing files, make sure they are not too big. Send your work as a low-resolution attachment in an e-mail with a short written explanation and your details on disc with your own graphic packaging (see left) or send an introductory email directing the assessment panel to your Web site.

This image (left) was part of a submission sent as a low-resolution digital file that could be viewed easily on screen. Your portfolio can be sent at a later date.

circumstance, most colleges will also look at work in other formats. Some stipulate that it may be supplied digitally, provided a portfolio can also be viewed at the interview stage. Other options may include digital photographs or original digital work sent through on e-mail, disc or uploaded to a portfolio service or even a link to your own or a host Web site. In the US, a National Portfolio Day has been set up in several locations to bring art school hopefuls and representatives together. Visit *www.portfolioday.net* for details.

What should accompany your submission of a portfolio?

1 The "Artist Statement" is an integral part of the portfolio process. It is a written declaration of your artistic sensibilities, the artists and/or concepts that have influenced your work, an explanation of the focus and direction of your artwork, and the reason you want to attend the art school or college to which you are applying. For some courses the Artist Statement is an integral part of the portfolio process, whereas for others (e.g., CSM Graphic Design) the portfolio can speak louder than words. Dyslexic students need not worry about verbose statements if their work is strong.
2 You may be asked to include a biography that lists your previous background, education and artistic interests.
3 You may also be asked to include a CV. It should be brief and include your contact details, a chronological or functional outline of your educational, work and volunteer-related experience. It should also include any clubs, organisations or extracurricular activities that relate to your art background or artwork.
4 If you haven't done so already, you should include your sketchbooks or journals.
5 Consider the kind of course you are applying for. With hundreds of applicants, your 1,000-word CV is unlikely to be read in full. Focus more on what makes you an individual and try putting some personality and fun into your portfolio so it stands out. If the course you are applying to is small (for example, at postgraduate level), then details of your artistic qualities may well be of interest to the panel.

What makes a winning portfolio?

1 Follow the rules for portfolio submissions as outlined in your college catalogue through your admissions office or art school online resources.

2 Make it visually strong and aesthetically appealing. Start with a bang and end with a bang!

3 Don't include artwork that is over one year old. Your collection should be your most recent work.

4 You may be asked to choose a limited number of artworks. Be selective. Make it your best work. If in doubt, don't include it.

5 Your work may include lots of varied pieces. Think about how you want them ordered. Decide on a theme or context and run through it with a friend or teacher to see what they think.

6 Your work might explore (and show how you approached) a given subject. It might outline how you responded to a certain theme in a personal way. This research should inform the development of your ideas. Keep a journal critiquing your work as it progresses. The entire portfolio should be underpinned by thorough and wide-ranging research about the subject in the form of sketchbooks, journals, photography, films, even relevant ephemera.

7 Use these guidelines to edit your work.
- Are there many similar pieces in your portfolio already? If so, edit them down.
- Is your portfolio inventive? Don't copy material or mimic the styles of other artists.
- Does it show a process of thinking?
- Are you demonstrating a particular set of skills: a fantastic drawing ability, an interest in typography or the moving image, or perhaps simply a wide range of basic skills?
- Does your personality and the way you express yourself visually shine through in the portfolio?
- Don't take yourself too seriously. Show you have a sense of humour.
- Is your portfolio aesthetically pleasing? Does it challenge perceptions? Is it full of surprises?

8 In an increasingly technology-based world, portfolios that show good observational skills in drawing are popular, where good drawing skills can be transferred into other disciplines. Tutors are not looking for fully rounded mini professionals but for applicants who show promise.

The next few pages showcase work from the portfolios and sketchbooks of students admitted to the University of the Arts London. Although each piece contains elements that all tutors look for, the artworks are grouped into content-related themes. They are all examples of successful portfolios that caught the eye.

Experimentation

Burnt edges, shadows and spattering are components beyond an artist's control and used to create striking images here. These three pieces (below) show an interest in exploring the unexpected and exemplify the process of engaging in experimentation with an openness of mind.

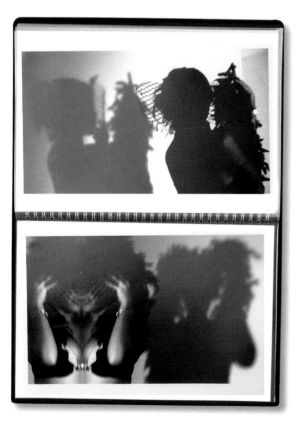

Composition

The sense of "compositional awareness" in these complex, multi-image, multi-technique submissions is very strong. Words and pictures have been layered to show an understanding of the placement of elements on the picture plane (right). You can see an instinctive understanding of shapes and colours, combined with personal inventiveness.

These pages drawn from life show observed portraits around the theme of body language. The progression to an interlocking pattern shows an original approach and a sense of playfulness that appealed to the selection panel.

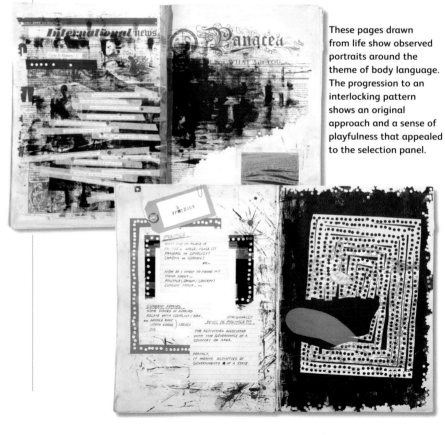

Working through an idea

The ability to explore an idea or theme, resolve issues of space, pattern, texture, colour, message, communicate meaning, as well as follow a visual starting point to unexpected places, are all aspects that are considered during the evaluation of submissions. Here the analogy that a hillside village is like a bees' honeycomb (below) is explored over several pages in the sketchbook.

Restraint and entrapment, both physical and mental, are the initial ideas here (left). The imagery takes the form of personal collages of ephemera, including strands of hair, splashes of "blood", letters, safety pins, barbed wire, photographs and old engravings. Very sophisticated in its concept, the imagery presents a multi-layered approach. The student shows an understanding of how to experiment and work through a concept to discover solutions.

A sketchbook progression from a series of observed portraits is used as the basis for exploring tesselations (below).

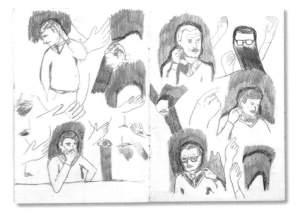

Specialisation

Your portfolio or sketchbook might show elements of art specialisation within a more general field. The work could be moving towards areas such as illustration, graphic design, fine art, sculpture, films or advertising. The following pages look at samples where students have shown inclinations in a particular direction.

Illustration

This artist has written a story and used a foil-blocking technique (left and above). Some illustration courses welcome such evidence of deep-level thinking; others look for other criteria. Do your research before applying.

Book and editorial design

The nature of "antique" objects like old books makes them unique as part of any submission. Explore the nature of the book, challenging and questioning its form and construction. Note how the object (above) is here deconstructed, pages are cut, illustrated and then re-assembled in different ways.

Moving image

You might want to include the moving image in your submission. Check with a college beforehand to make sure they can view such material. In any case, be sure to show the thinking and logic behind your work. These three examples (below) include a traditionally drawn storyboard, a flexible version using post-it notes and a storyboard using snapshots of an anthropomorphic hand.

Graphic design

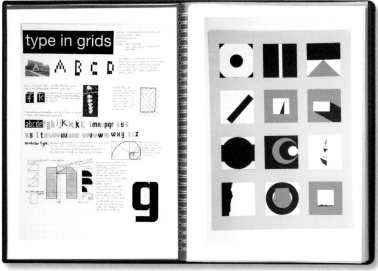

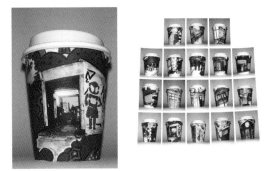

Some early ideas about what makes up a font and how graphic icons develop (above). These ideas demonstrate an interest in branding and corporate design.

These graphic ideas (above) are satisfyingly loose and experimental. Not too polished at this stage, they evidence a willingness in the artist to explore and an interest in icons and 3D design.

A combination of loose drawing with hand-drawn type (above) shows an applicant who is capable of combining different skills. Lots of portfolios show separate examples of disciplines but the ability to mix-and-match is part of any art or design course.

LUKE DABBIE HARUNA

The "talking hand" storyboard (left) shows clarity and a simple idea. Even if you do not include a digital submission, this would be understood by the tutors because of its directly graphic message.

Observation and photography

Using photography as a way of expressing yourself and communicating your view of the world is an insightful way of showing the admissions panel your unique take on daily life. How do you see and isolate the seemingly normal and elevate
it into something special?
The ability to see is not just
the domain of photographers.
It permeates all fields of art.
Using a camera in the way you
would a sketchbook helps you
to train your eye and develop a
visual language of your own.

These portrait and fashion
shots (right) show an
innate sense of drama and
composition plus a sense of
ease behind the camera.

A multi-faceted view of
different urban scenes (far
right) becomes an intriguing
compositional proposition in its
own right.

Resources

Birmingham Institute of Art and Design (BIAD)
One of the largest faculties of art, design and media education in the UK.
www.hereford-art-col.ac.uk/

British Arts
Useful portal to several leading UK art college Web sites.
www.britisharts.co.uk/artcolleges.htm

Camberwell College of Arts (University of the Arts London)
One of the UK's foremost art and design institutions.
www.camberwell.arts.ac.uk/

Central Saint Martins (University of the Arts London)
Cutting-edge specialist education and research in fine art, fashion and textiles, film, video and photography, graphics and communication design, 3D design, and interdisciplinary art and design.
www.csm.arts.ac.uk/

Chelsea College of Art and Design (University of the Arts London)
Fine art, graphic design communication, installations and textile design.
www.chelsea.arts.ac.uk/

The Glasgow School of Art
One of Britain's foremost higher education institutions for the study and advancement of fine art, design and architecture.
www.gsa.ac.uk/

Goldsmiths University of London
Creative and unconventional approaches to fine art and textiles.
www.goldsmiths.ac.uk/

Hereford College of Arts
Students as young as sixteen can study alongside undergraduates, artists and designers at this specialist art and design college.
www.hereford-art-col.ac.uk/

The portfolios of these two young photographers (above) show a keen sense of composition and the delightful ability to see beauty even in ordinary scenes. They are a pleasure to view. Unusual cropping and an interesting choice of subjects reveal a keen photographic eye. At Central Saint Martins, for example, the reputation of a strong visual culture attracts talented students of this kind.

Manchester College of Arts and Technology
Over 500 courses aimed at all levels, from basic skills to higher education.
www.mancat.ac.uk/

Plymouth College of Art and Design
One of only four independent art and design colleges in the UK.
www.pcad.ac.uk/

University College Falmouth
Cutting-edge technology with a commitment to personal development and academic excellence.
www.falmouth.ac.uk/

Slade School of Fine Art
Studio-based painting, sculpture and fine art media programmes.
www.ucl.ac.uk/slade/

All of the portfolios featured on these pages were kindly submitted by students who applied for the full-time BA Honours Graphic Design course at Central Saint Martins School of Art and Design (part of University of the Arts London). Their names appear on page 128. Course Director Alan Baines says, "We select students by choosing portfolios that show individuality and have interesting approaches. Selection can be hard, however, so make sure that you enjoy putting your portfolio together." Cath Caldwell and Robert McCaulay, first-year tutors advise to "be yourself and put your own personality in the work. Don't second-guess the selectors. Make sure the course sounds right for you. Don't rely on hearsay but find out by visiting the colleges on their open days. Talk to students there. Go and see degree shows when they are open to the public."

Glossary

Abstract art Type of art in which the artist relies on colour and form instead of choosing to portray the subject in a realistic or naturalistic way.

Abstract expressionism School and style of painting based on the expression of the subconscious.

Acrylics Quick-drying, permanent and colourfast, pigments in this comparatively new form of paint are suspended in a synthetic resin.

Aerial perspective The use of colour and tone to denote space and distance.

Alla prima Direct form of painting (Italian for "at first"), where the picture is completed during one session with each colour laid on more or less as it will appear in the final painting. The Impressionists worked in this way, in contrast to the academic painters of the nineteenth century, who built up their paintings layer by layer over a monochrome.

Backruns In watercolour painting, jagged-edged blotches will sometimes occur when new paint is added into a wash that has not fully dried. Backruns can look unsightly if the colour area is intended to be flat, but can be attractive features in a painting and are often deliberately induced by watercolourists painting wet-in-wet.

Binder The liquid medium that is mixed with pigment to form paint or pastel sticks. The binder used for watercolour is gum arabic. Oil paints are bound with oil, acrylics with synthetic resin, and pastels with gum tragacanth.

Blending Achieving a gradual transition from light to dark, or merging colours into one another so the joins are invisible.

Blocking in Initial painting stage when the main forms and composition are laid down in approximate areas of colours and tone.

Calligraphy The art of beautiful or decorative writing. Broadly, a flowing use of line, often varying from thick to thin.

Canvas A heavy woven fabric, the most commonly used support for oil painting and also frequently used for acrylics.

Cartoon A drawing or sketch, sometimes containing an element of caricature, showing the comic side of a situation.

Collage Technique of forming a picture by pasting any suitable materials (pieces of paper, photos, news cuttings, fabrics) onto a flat surface.

Color field painting Developed in the USA in the 1940s and 1950s, this type of abstract painting uses large areas of flat, unbroken colour.

Composition The arrangement and combination of elements in a picture.

Crosshatching Technique for building up areas of shadow with layers of criss-cross lines instead of solid tone.

Cubism Art style developed in 1908 by Picasso and Braque whereby the artist breaks down natural forms into geometric shapes and creates a new kind of pictorial space. Unlike traditional painting styles, where the perspective is fixed and complete, Cubist works portray a subject from multiple perspectives.

Expressionism Art movement of the early twentieth century in which adherence to realism and proportion was replaced by the artist's emotional connection to the subject. These paintings are often abstract, the subject distorted in colour and form to emphasise and express the intense emotion of the artist.

Fat over lean The expression "fat over lean" refers to the traditional method of using "lean" colour (paint thinned with turpentine) in the early stages of a painting and working over this with "fat" or oily paint as the painting progresses.

Frottage Technique akin to grave-rubbing, in which a piece of paper is placed over a textured or indented surface and rubbed over with a soft pencil, crayon or pastel stick. Designs or textures created in this way are often used in collage work.

Figurative painting A painting of something actual, as opposed to an abstract painting. It does not imply the presence of human figures.

Foreshortening The optical illusion of diminishing length or size as an object recedes from you.

Glazing Technique of applying oil or acrylic colour in thin, transparent layers so that the colour underneath shows through, modifying the pigment of the glaze. Overlaid washes in watercolour are sometimes used as glazes but this is misleading since all watercolour is transparent.

Golden section System of organising the geometrical proportions of a composition to create a harmonious effect. Known since ancient times, it is defined as a line divided in such a way that the smaller part is to the larger part what the larger part is to the whole.

Gouache Opaque watercolour akin to poster paint.

Hatching Shading technique of using parallel lines to indicate form, tone or shadow.

Horizon line Imaginary line that stretches the subject at your eye level, and is where the vanishing point or points are located. The horizon line in perspective should not be confused with the line where the land meets the sky, which may be considerably higher or lower than your eye level.

Impasto Thick application of paint or pastel to a picture's surface in order to create texture.

Lean Term used to describe oil colour with little or no added oil. The expression "fat over lean" refers to the traditional method of using "lean" colour (paint thinned with turpentine) in the early stages of a painting and working over this with "fat" or oily paint as the painting progresses.

Lifting out Technique used in watercolour and gouache work, involving removing wet or dry paint from the paper with a brush, sponge or tissue to soften edges or make highlights. Wet paint is often lifted out to create cloud effects.

Impressionism Late-nineteenth-century French style of painting that opted for a naturalistic approach using broken colour to depict the atmospheric and transforming effects of light. It is characterised by short brushstrokes of bright colours that recreate visual impressions of the subject and capture the light, climate and atmosphere at a specific moment in time. The chosen colours represent light broken down into its spectrum components and recombined by the viewer's eye into another colour when viewed at a distance (an optical mixture).

Mixed media Technique of using two or more established media, such as ink and gouache, in the same picture.

Negative space Drawing or painting the space around an object rather than the subject itself.

Op art Also called Optical Art, a style of visual art that uses optical illusions, flat colour and hard edges. Also known as geometric abstraction and hard-edge abstraction, the preferred term for it is perceptual abstraction. Optical Art works are concerned with the interaction between illusion and the picture plane. The viewer is given the impression of movement, hidden images, flashing and vibration, patterns and swelling or warping.

Optical mixing In an image, the juxtaposition of blobs of colours so they intermingle to give the illusion of another colour. The pigments do not actually mix but seem to in the eye of the viewer when seen from a distance.

Palette The flat surface used to mix colours or the pigment selection of the artist.

Perspective Systems of representation in drawing and painting that create an impression of depth, solidity and spatial recession on a flat surface. Linear perspective is based on a principle that receding parallel lines appear to converge at a point on the horizon line. Aerial perspective represents the grading of tones and colours to suggest distance that may be observed as natural modifications caused by atmospheric effects.

Picture plane The space occupied by the physical surface of the drawing. In a figurative drawing, most of the elements appear to recede from this plane.

Pointillism Technique of applying colour in dots rather than in strokes or flat areas.

Post Impressionism This French movement paved the way for early twentieth-century modernism and was both an extension of Impressionism and a rejection of its limitations. Coined by English art critic Roger Fry, it references works by Paul Cézanne, Georges Seurat, Paul Gauguin, Vincent van Gogh, Henri de Toulouse-Lautrec and others. All except van Gogh were French and most began as Impressionists, although each later abandoned this style for a more highly personal art. While owing a debt to Impressionism for its freedom from traditional subject matter and its technique of defining form with short brushstrokes of broken colour, the Post Impressionists rejected the objective recording of nature in terms of the fugitive effects of colour and light in favour of more ambitious expression.

Primary colours In painting, red, blue and yellow. These pigments cannot be obtained from other colours.

Realism Art that takes its inspiration from everyday life.

Renaissance Cultural rebirth of classical ideas that started in fourteenth-century Italy and lasted through to the middle of the seventeenth century.

Sgraffito Technique of incising into a pigmented surface to create texture. Any type of mark can be created using any sharp instrument, from a pin to your fingernail.

Surrealism Developed in 1920s Europe, style of art characterised by the use of the subconscious as a source of creativity to liberate pictorial subjects and ideas. Surrealist paintings often depict unexpected or irrational objects in an atmosphere of fantasy, creating a dream-like scenario.

Tone Also known as value, the lightness or darkness of any area of the subject, regardless of its colour. Tone is only related to colour in that some hues are naturally lighter than others. Yellow is always light in tone, whereas purple is always dark.

Trompe l'oeil Form of painting first used by the Romans thousands of years ago in frescoes and murals. Objects are rendered in fine detail to create the illusion of tactile (tangible) and spatial qualities. The French phrase means "deceives the eye" and is applied to paintings (or objects in paintings) that trick the onlooker into believing something is solid instead of a two-dimensional illusion.

Viewpoint The angle at which an image is represented to provide the best aesthetic study or to emphasise particular elements in the composition.

Vanishing point In linear perpective, the point on the horizon line at which receding parallel lines meet.

Underdrawing Preliminary drawing in pencil, charcoal or paint over which the finished work is carried out.

Underpainting Preliminary blocking in of the basic colours that are used, the structure of a painting and its tonal values.

Wash Application of diluted colour spread transparently and thinly over a surface.

Wet-in-wet The application of watercolour to a still-wet surface which creates a subtle blending of colour.

Wet-on-dry Application of watercolour to a dry surface, causing the sharp, overlapping shapes to create the impression of structured form.

Index

Credits and acknowledgements

A special thanks to:

To everyone who worked on the book.

Moira Clinch, my creative director, for her creative vision and positive professionalism; to the talented editors, Liz Pasfield, Ruth Patrick and Anna Amari-Parker, and Anna Plucinska, the art editor; to my son, Joe Colston, who helped in countless ways and collaborated on the Vincent van Gogh tessellation project; and, finally, to my Nana, Reva May Imel, the first artist I knew and the person who taught me the value of art.

Tom Pearce and Jessie Coulson for their portfolios.

The publishers would like to thank the following artists:

Don Austen	Mark Duffin	Ronald Jesty	Montage Publications	Roy Sparkes	Viviane
Christopher Baker	Margaret Glass	Tom Kidd	Angela Morgan	Jake Sutton	Alison Willoughby
Lizzie Barker	Brenda Godsell	Sally Launder	Tom Pearce	Colin Taylor	(*49 Sensational Skirts*,
Paul T. Bartlett	Adrian Grandon	John Lidzey	Paul Powis	Martin Taylor	Interweave Press,
George Cayford	Elizabeth Harden	Audrey Macleod	Linda Ravenscroft	Michael Taylor	2008)
Moira Clinch	James Horton	Dan Malone	Ian Ribbons	Jim Thompson	Vincent Woodcock
Marjorie Collins	Jan Hart	Judy Martin	Rupert Shepherd	Will Topley	Jessica Wilson
Madeleine David	John Houser	Tomomi Maruyama	William Shumway	Jacquie Turner	

Thanks to those students who applied to the full-time BA Hons Graphic Design course at Central St Martins School of Art and Design, London, 2007:

Key: a = above, b = below, l = left, m = middle
r = right

p. 36 mr Haruna Sakai
p. 37 ml Fabiana Serpa
p. 116 l and bm Bartosz Babel; r Leoni Cicirello
p. 117 a Kim Kwang Su, b Marcos Dangas
p. 118 br Haruna Sakai; ml, bt, ar, mr Liana Kasenci; al Bartosz Babel
p. 119 tl and tr; ml and bl Haruna Sakai; br Mathew Whittington
p. 120 bl Mathew Whittington; mr Yuen Hsieh; a, m Shotave Ishii;
br Colin Taylor
p. 121 tl Leoni Cicirello; tr Marcos Dangas; m Bjørnar Pedersen;
b Haruna Sakai
p. 122 Angela McMahon
p. 123 l Leoni Cicirello; r Fabiana Serpa

Quarto would like to thank and acknowledge the following for supplying the illustrations and photographs reproduced in this book.

p. 28 ar Eileen Tweedy/Tate Gallery London/The Art Archive
p. 32 ar Summerfield Press/Corbis
p. 71 bl Art of Legend India *www.artoflegendindia.com*
p. 72 Darryl Sleath
p. 72 Nikita Tiunov
p. 72 Chris Zwaenepoel
p. 73 Jim Lipschutz
p. 77 Anna Amari-Parker
p. 80 CJ Photo
p. 82 Perov Stanislav
p. 85 br Kurt Wenner, *www.kurtwenner.com*
p. 88 bl National Gallery, London, UK/Giraudon/The Bridgeman Art Library
p. 89 Mike Liu
p. 94 Steve Luker
p. 94 Baloncici
p. 94 Dennis Owusu-Ansah